The Making of Rubens

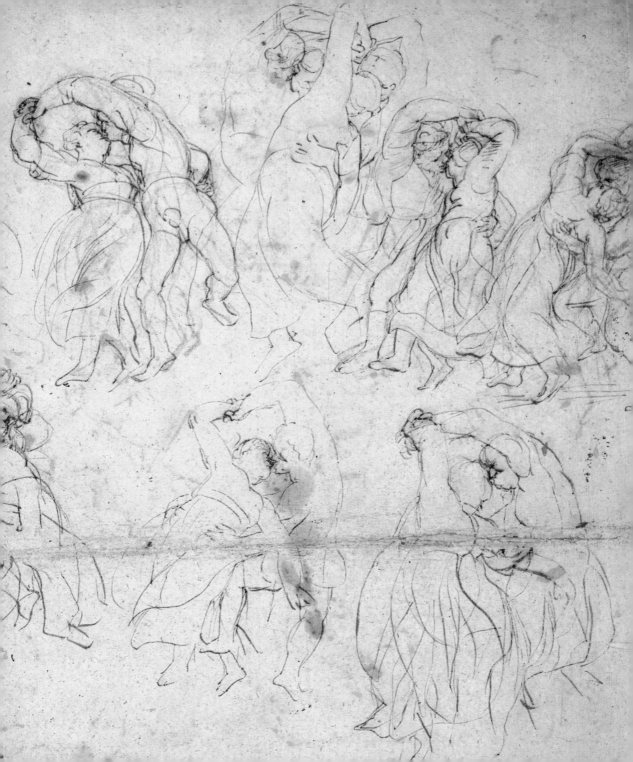

The Making of Rubens

SVETLANA ALPERS

Yale University Press
New Haven & London

Frontispiece: Detail from a sheet of studies of a dancing couple (see pl. 29). British Museum, London.

Copyright © 1995 by Svetlana Alpers
Second printing, 1996

Designed by Gillian Malpass
Set in Bembo by Best-set Typesetter Ltd., Hong Kong
Printed in Hong Kong through World Print Ltd

Library of Congress Cataloging-in-Publication Data

Alpers, Svetlana.
 The making of Rubens/Svetlana Alpers.
 Includes index.
 ISBN 0-300-06010-6 (hbk)
 ISBN 0-300-06744-5 (pbk)
 1. Rubens, Peter Paul, Sir, 1577-1640—Criticism and interpretation. I. Title.
 ND673.R9A79 1995
 759.9493—dc20 94-30637
 CIP

A catalogue record for this book is available from The British Library

Contents

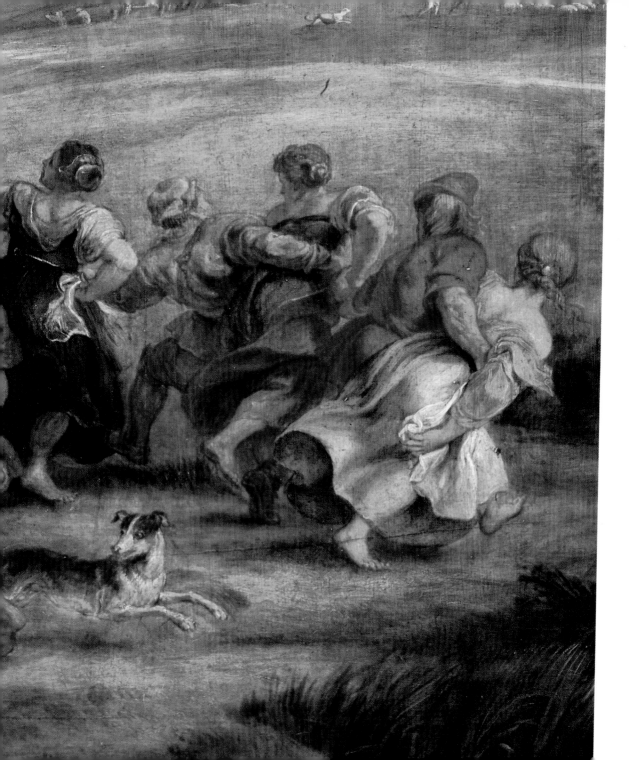

Preface

This book has been long in the making. Thanks are overdue to those institutions that invited me to present this material as lectures or seminars: the Kress Department of Art History at the University of Kansas where I gave the Franklin D. Murphy Lectures; Rutgers University where I gave the Mason Gross Lectures; and the Ecole des Hautes Etudes en Sciences Sociales. For the luxury of free time to think, read and write, I thank the Getty Center for the History of Art and the Humanities, and the Wissenschaftskolleg in Berlin where, at last, the book came to an end.

Portions of chapter two have appeared in *Wölfenbütteler Forschungen* 48, 1991 and in *L'Histoire de l'histoire de l'art*, a volume of lectures to be published by the Louvre.

Many people have answered questions and offered information, comments or criticisms over the years. In the notes particular people are thanked for particular points. Though some may by now have difficulty remembering the reason, I wish in addition to thank Paul Alpers, Kristin Belkin, Richard Dorment, Hubert Damisch, Marc Fumaroli, Linda Graham, Julius S. Held, Louis Marin, Jeffrey M. Muller, Thomas G. Rosenmeyer, Lisa Rosenthal, Linda Stone-Ferrier, Andrew Stewart, Carl van de Velde, and Jan de Vries. Sharon Hecker was the genial indexer.

I am grateful to Yale University Press, London for the good will and skill with which they produced this book, particularly to Sheila Lee, who assembled the photographs with care and perseverance, and to John Nicoll and Gillian Malpass, who gave keen advice about the design and were resourceful and responsive through the process of transforming manuscript into book.

The book would not have been finished without the help of two scholar/friends. Elizabeth McGrath responded in generous detail to my frequent queries about any number of Rubens issues. Margaret Carroll has been an intellectual *copain*, ready with suggestions, disputing, always ready to read another draft, always encouraging.

Michael Baxandall directed me back to the images when words led me away and offered words when they failed me.

<center>★ ★ ★</center>

A few points about format. All citations from Rubens's letters will be given, if available, in the language in which he wrote them followed by the English translation of Magurn. To avoid a break in reading, references to notes are normally made at paragraph ends. Unless otherwise indicated, all measurements of works of art are in centimeters, height before width, and the artist is Rubens.

Introduction

Rubens is an artist more admired today than loved – hugely talented, impersonal in manner, comfortable with the pictorial and the political establishment of his time. He has been the quintessential art historians' artist because his life and works seem to fit the preferred categories of research: that is to say, he was exemplary in his relationship to traditions both artistic and literary, in his manner of invention, his workshop organization, his collecting of art, his keeping up of a public correspondence, and, last but not least, in his involvement with rich and powerful patrons. With the return to an interest in ideology and figuration on the part of artists and critics alike, his pictorial versions of absolutism might receive some attention. But unlike his contemporary Rembrandt, Rubens has not been of compelling interest to the late twentieth-century world.

This book began some years ago as an account of the painting of the *Kermis* – the celebration of a saint's feast day – in the Louvre (pl. 1). It was prepared for a 1977 homage to Rubens on the four hundredth anniversary of his birth. Begun as an overly confident account of artistic making, it has changed and grown in unexpected ways. I have let myself be led by a series of links – or so I have felt them to be – from the life and circumstances of one painting, to the after-life created by the taste of viewers and artists who followed and, with these viewings in mind, back to consider the artist as maker.

The first chapter tests how far a circumstantial analysis takes one in understanding the production of a single painting. Since it deals with a picture of Flemish peasants, it considers the question of national allegiance and Rubens's problem of registering this in

painting. It concludes on a skeptical note to which the following two chapters offer alternatives.

The second chapter takes up the matter of artistic consumption. Art, on this account, is made out of a certain viewing of earlier art. I examine the system of taste for Rubens, as distinguished from Poussin, constructed in the writings of Roger de Piles (1635–1709), the leading French writer about art before Diderot, and take up the paintings that were made out of it. This is an artistic system within which distinctions came to be fashioned, and refashioned, in terms of gender.

With this engendering of art in place, the final chapter returns to Rubens to consider his self-identification with the fleshy, drunken figure of Silenus, whose disempowerment is the condition for the pouring out of songs. The making of Rubens is not only a matter of circumstances, or of the viewing of his art, it is also a matter of his own activity as a painter. It seems odd to have to say this at all. But consideration of human creativity and of generation is out of fashion. A motif of the book is that Rubens's drawing and painting provokes one to confront this anew.

Two final and related points: the trail leading from the making of the *Kermis* to the taste for Rubens, and on to the *Silenus* has produced a book much concerned with French taste for Rubens. The *Kermis* in the Louvre was bought by Louis XIV, and the *Silenus* (pl. 63), now in Munich, as well as the St Petersburg *Bacchus* (pl. 100), came to the duc de Richelieu from the collection Rubens made of his own works. A surprising number of the paintings we shall be looking at had been kept by Rubens in his own collection. Though they do not quite fit the category of Rubens's repeatedly mocked "fat women," pictures such as these have not been much in vogue. The French taste for a bacchanalian Rubens corresponds to Rubens's own inclination.

In addition, the French taste brings to the fore alternative ways of writing about art: the French tradition of criticism stands in an eccentric relationship to the academic study of art history. Critical writing about painting flourished in seventeenth- and eighteenth-century France in a different form than in the German lands. Put simply – perhaps too simply – while in Germany a taste for painting was a matter of validating standards grounded in the

nature of the human mind, in France it was a matter of educating a new class of collectors in discriminating looking and talking. Academic people came to play a greater role in the formation of taste in Germany, connoisseur/writers in France. Though there are, of course, many other strains, art-historical writing as we have known it – Rubens as he is now written about – is in the university mode. Might it be differently done?

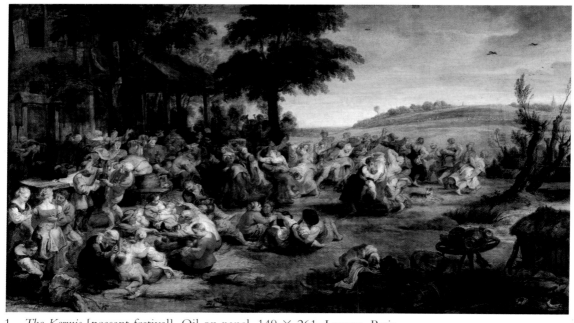

1 *The Kermis* [peasant festival]. Oil on panel, 149 × 261. Louvre, Paris.

Chapter 1

Painting in Flemish: The Peasant *Kermis*

Why an interest in the *Kermis*?[1] Our notion of Rubens is less the
peasant *Kermis* (pls. 1, 4–12) than works that hang nearby in the
Louvre – the great series of paintings the Flemish artist was
commissioned to make of the life of the French queen Marie de'
Medici. Rubens is here serving, as he so often did, as celebrator
of and apologist for European monarchs of the time. Let us take,
for example, the *Arrival of Marie de' Medici at Marseille* (pl. 2), a
large, public picture, four by three meters, designed to hang in
the Luxembourg Palace. It represents the arrival of the Italian
woman on French soil on her way to meet her new husband,
Henry IV of France. In Rubens's painting, her disembarkation
from the ship is enriched by allegorical figures – France and
the city of Marseille – and figures from myth – Neptune and
Triton and three naiads, Rubens's ubiquitous, fleshy nudes,
frolicking in the waves. The fine invention combines history,
allegory, and the nude, in parts presented in the rather slick
execution of Rubens's studio assistants without whom he would
have been unable to produce the great number of works and
public commissions that he did.[2]

For sheer talent, Rubens ranks with Picasso as having the
greatest facility in our pictorial tradition, and also, like Picasso, he
had enormous confidence in himself as a maker. But unlike
Picasso, Rubens lived at a time when the public demands on and
expectations of painting were clear. Rubens's intentions as a
painter were bound up with the public circumstances of his time.
Kings and queens saw and understood themselves and their rule
through Rubens's brush.

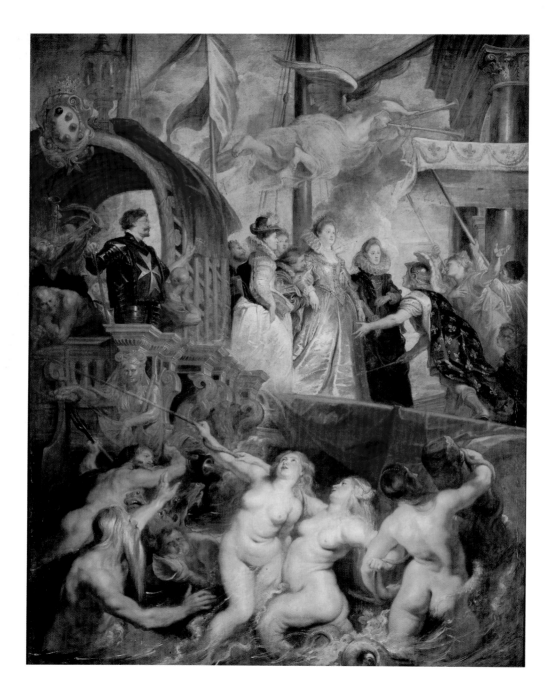

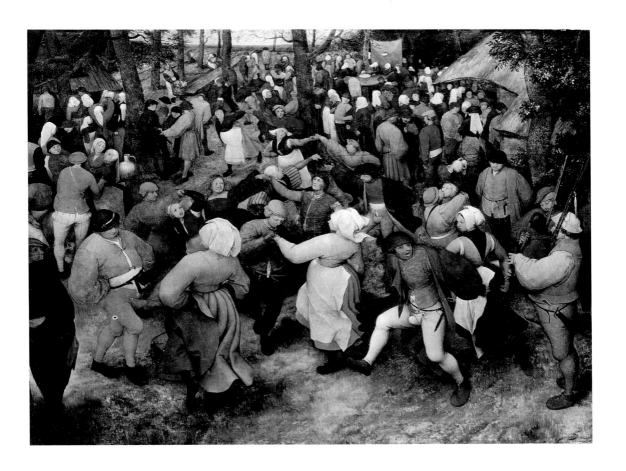

3 Pieter Bruegel, *Wedding Dance in the Open*. Oil on panel, 119 × 157. Institute of Arts, Detroit, Purchase; City Appropriation.

2 *The Arrival of Marie de' Medici at Marseille*. Oil on canvas, 3.94 × 2.95. Louvre, Paris.

An interest of the *Kermis* is its apparent difference from productions of this public kind. It is the painting in which Rubens most explicitly takes up the Flemish peasant tradition of his great predecessor Pieter Bruegel (pl. 3). It is large, in particular wide, for this kind of peasant theme: painted on panel, it measures about 1½ by 2½ meters (149 × 261 cm.) compared to Bruegel's panels which are normally about 1 plus by 1½ meters (119 × 157 cm.). It is unfortunate that we do not know for whom, if anyone, it was painted. Its ambitious size alone suggests that it might have been a commissioned work. The resolution of the issue might turn on the hands involved. It is less likely to be a

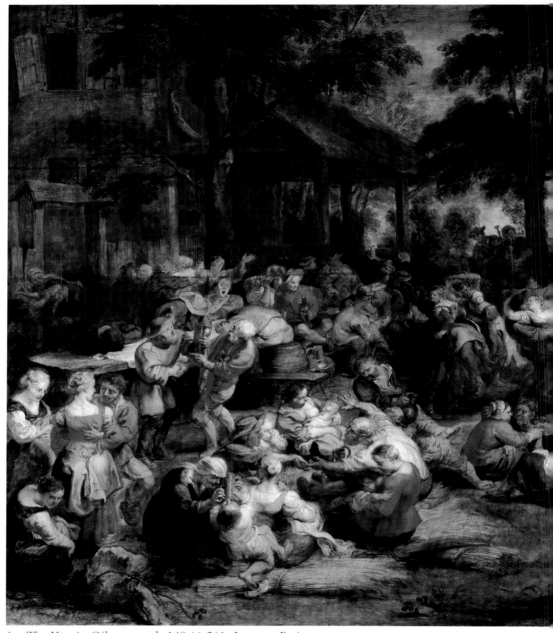

4 *The Kermis*. Oil on panel, 149 × 261. Louvre, Paris.

commissioned work if it is painted – and this is rare for Rubens except in his last decade – entirely by his own hand and hence maybe for his own pleasure. The painting was recorded on 4 April 1685 as being bought, along with a *Noah* by Jacopo Bassano, on behalf of Louis XIV from a son of the marquis d'Hautrive, who had served as the French military commander in Breda. Rubens's peasants were first hung at Versailles. They were taken from there to the Luxembourg Palace, where in 1770 a new backing was authorized because dampness had caused the panel to split, and they were finally moved to the Louvre. Though we call it a *kermis*, it was known as the *Noces de Village* or Village Wedding when it was in the collection of Louis XIV.[3]

It is a puzzling image in many respects: wonderful in the refinement and also the gravity Rubens gives to liberated behavior, but also flawed. It is, first of all, not pleasant. It does not make us smile as Bruegel's *Wedding Dance*, for example, can do (pl. 3). John Ruskin, on a visit to the Louvre in 1849, looked at Rubens's painting and was revolted:

> A crowd of peasants near some place, drinking, dancing like baboons, hauling each other by the part of the body where a waist should be, kissing and – men and women alike – fighting for pots of beer. I never thought Rubens vulgar til today . . . For there is no joy of colour, no fine form, no drollery; it is unmitigated brutality: if meant as a satire on drunkenness, well; but I cannot conceive a good man enduring to paint it, bearing the sight of his own imaginations. A pig puts his snout out of a stye in the corner; and two ducks carefully painted, occupy the nearest gutter.[4]

Ruskin exaggerates and is perhaps unfair, but his description of (some of) what it contains is not untrue. In modern studies of Rubens, the *Kermis* has characteristically been one of the most fully described of Rubens's works. The sheer number of figures, the complexity of their gestures and the nuanced working of the paint, at once constructive and summary, with which they are rendered invite and satisfy a close viewing. Writers have repeatedly catalogued the vomiting, drinking, urinating, love-making and dancing of the myriad figures. Even the foreground pig has

5–12 (facing page and pages 12–19) Details from *The Kermis* (pl. 1).

10

Plate 9

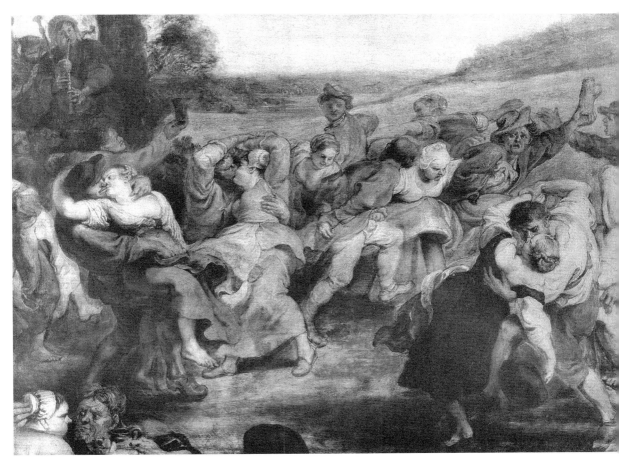

Plate 10

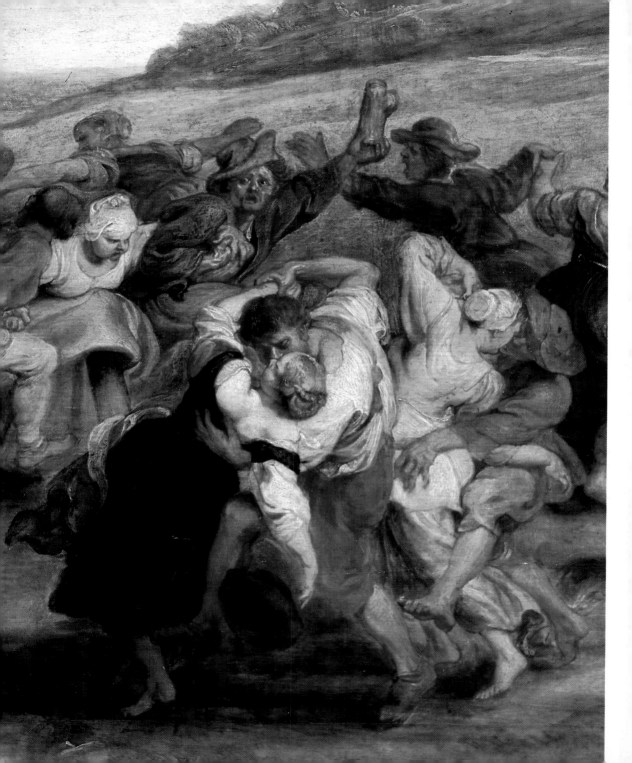

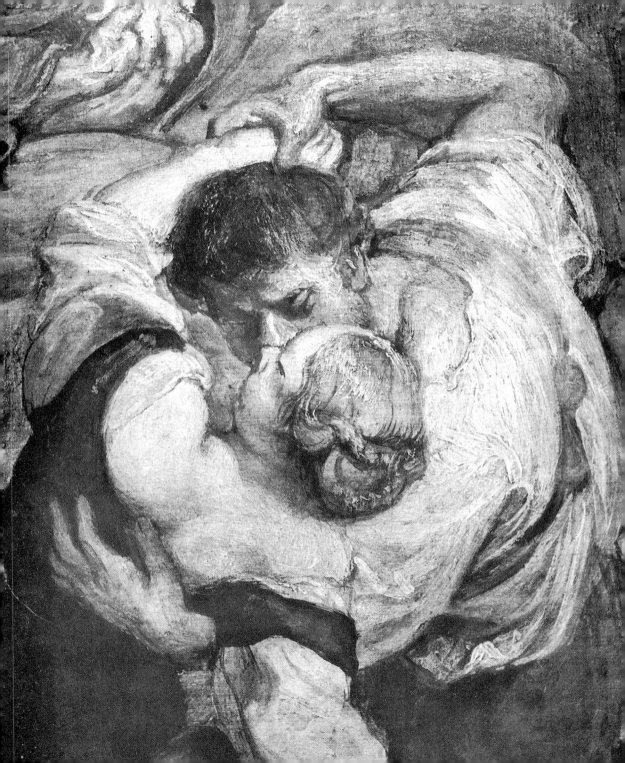

come in for comment. But modern viewers have not drawn such a sharp line between Rubens's peasant debauchery and the bacchic pleasure of gods and goddesses. In fact, Rubens's *Kermis* is usually defined in the art-historical literature with coupled reference to bacchic pleasure and to antiquity. The *Kermis* has been called a peasant bacchanal, a rustic bacchanal, a depiction of a rustic Venus, and a *kermis* in the proportions of an Homeric ballad. Writers who use phrases such as these assume that Rubens was consciously engaged with the ancient origins — both textual and visual — of his festive theme. It is in this respect that he introduced a larger, more civilized context into Bruegel's depiction of the Flemish peasants.[5]

The point is confirmed if we look at the *Kermis* as seen by the eighteenth-century French painter Antoine Watteau (pl. 13). A red-chalk drawing (one of several studies after it made by him) concentrating on the splendid dancing embrace of the most prominent couple is a record of seeing the *Kermis* in this elevated way. Sustained by Rubens's example, Watteau captures and refines the powerful display of desire and sexual passion. Isolated in this way, the couple carry with them hardly a trace of their former surroundings.

In effect, commentators have subsumed Ruskin's discomfort about what even an admirer of Rubens has called his "love of revolting subjects" into an appreciation of Rubens's art. Despite the vulgar nature of certain passages, it has become commonplace to insist that out of such materials — the crude, vulgar details of Flemish rural festivity — Rubens made great art. Jacob Burckhardt put this way of seeing the painting succinctly:

> The *Kermis* at one blow delivered the doings of the peasant from the manner of the Brueghel workshop, from the imperious rule of the individual in type and incident. It gives them perfect freedom, and variety of movement, perfect unity of incident, tonality and colour, adding only as much of the locality as may serve the total effect.

(Die Kermesse befreit das Bauerntreiben mit einem Mal vom Stil der Breughel'schen Werkstatt, von der scharfen Herrschaft des einzelnen in den Typen und in den Spässen; sie versetzt

13 Antoine Watteau, *A Dancing Couple*. Red chalk, 23.3 × 14.7. Musée des Arts Décoratifs, Paris.

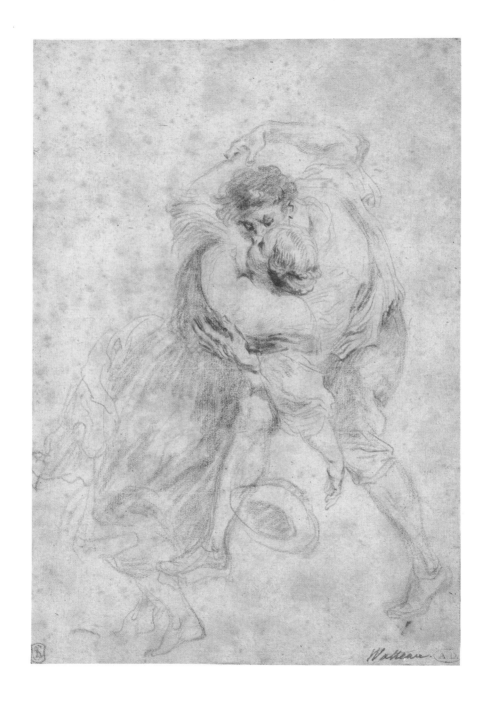

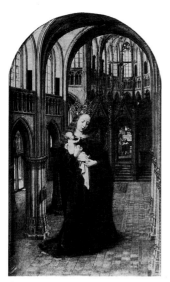

14 Jan Gossart, *Virgin and Child*. Oil on panel (left side of a diptych), 41 × 24. Palazzo Doria, Rome.

15 Jan Gossart, *Neptune and Amphritite*. Oil on panel, 188 × 124. Staatliche Museen, Berlin.

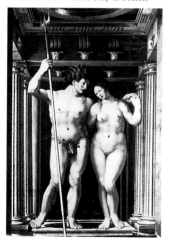

dasselbe in das Reich der völlig freien und reichen Bewegung, der Einheit von Moment, Klang und Kolorismus und giebt dabei von der Oertlichkeit nur so viel mit, als der Gesamtwirkung dient.)[6]

This is splendid as a tribute to the general power of the work, but Burckhardt's Italian bias is showing. He makes what he acutely calls the "locality" of the work a secondary rather than an essential part. In effect, he smooths over the coarse detailing of the peasants and their behavior in the name of the unity and general effect which he attributes to Rubens's art. (Another *Peasant Dance* by Rubens, a spin-off from the *Kermis*, originally called *A Dance of Italian Peasants*, answers better to such a description [pl. 35]).[7]

To anyone acquainted with Rubens (and in particular with art-historical writing about his works), this has a familiar ring. He is the northern artist who notoriously succeeded (as Dürer had tried with less success a century before) in employing the skills and art of the Italian tradition. He succeeded in taking on what was in a deep sense a foreign way of painting, but, more significantly, that tradition that had established the dominant practice and also conception of Art in Europe. It was in part by taking this path that Rubens became the international favorite among painters of the age. In works as diverse as the portrait of his naked wife known as *Het Pelsken* (pl. 16) or the *Massacre of the Innocents* (pl. 17), such an account might go, Rubens fulfills the aims and crowns the achievements of Italian Renaissance picture-making by bringing together observed nature and an ideal view and ordering. To which one might add, taking up a maxim of Max J. Friedlaender, that in doing so Rubens also solved the problem in scale and finish that implicitly confronted sixteenth-century painters in the north looking south: how to paint at once as small as Van Eyck and as large as Michelangelo. (The problem is succinctly presented in the split pictorial identity of Jan Gossart [1470/80–1532]: compare his Eyckian *Virgin and Child* [41 × 24] and his Michelangelesque *Neptune and Amphritite* [188 × 124] [pls. 14, 15]). Rubens's *Massacre of the Innocents* (199 × 301), for example, presents us with detailed descriptions of the infants' bodies and the contorted features of their frantic mothers and the

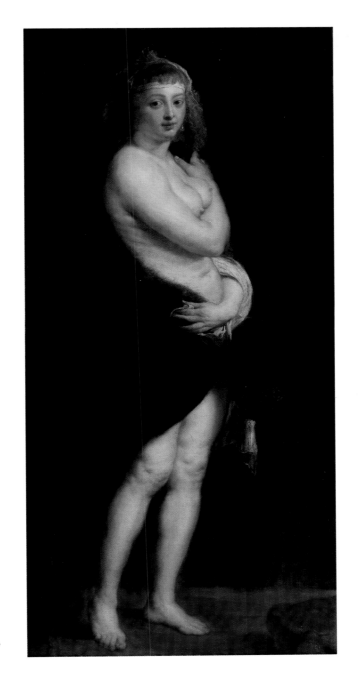

16 *Het Pelsken*. Oil
on panel, 176 × 83.
Kunsthistorisches Museum,
Vienna.

17 *The Massacre of the Innocents.* Oil on panel, 199 × 302. Alte Pinakothek, Munich.

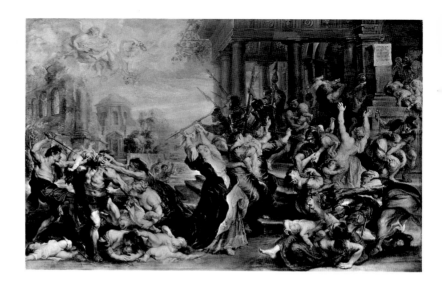

attacking soldiers. It also employs the hallowed pose of the Laocoön for the soldier to the left and an established heroic figure of human despair for the mother in the center. It is predictable, on the basis of pictures like these, that Rubens would turn a peasant festival into a peasant bacchanal.

With the exception of Ruskin, who judged its vulgarity to be a mark of its failure, commentators have directed their attention to Rubens's rising above the vulgar peasants as if they were already his to transform into art and the picture the transformation accomplished. But the combination of low and high is only part of the matter. Though consistent with views of his other works, this end-game view ignores the oddities peculiar to his *Kermis.* Rubens was trying to come to terms with something. He was not attempting to escape from the rude Flemish peasants but trying to find the means to take up their representation.

The oddities of the picture seem to register difficulties encountered. The painting in the Louvre can be and has been marvelously reproduced in its details. But it must be admitted that the reproduction of the whole, like one's first general view of it in the gallery, is disappointing. There is a disparity between the figures so fluently painted when viewed near and so dimin-

ished in appearance – as if they are too small or the format too large – when viewed from afar. Immediate in its rendering of details, the painting is willfully ordered to encourage a distant, unified view of the whole seen as if from above in the manner of the old Bruegel. A diagonal clearing, as if a line were drawn from the lower corner with the squatting woman by the feasting and love-making figures and the dancers, and out to a church steeple against the horizon, is more subtly matched by a sequence of raised hands which pass mugs back and forth across the panel from the tavern out towards the dancers, and the landscape. One can see this play of hands only close up. Rubens's evident love of working the paint as we find it in the figures at table at middle left, in the hands, or in the tawny, monochromatic still life that takes up the lower right corner (almost Chardin-like in tone and execution) is challenged, shaped, controlled by compositional devices.[8]

Why did Rubens take up the peasant subject in the first place? How can we explain his concern to depict the peasants at this moment? What were the circumstances in Flanders – I shall, as is customary, use the name of the province to refer to the entire Spanish Netherlands – and Rubens's attitude towards them at the time he painted the *Kermis*? How far can they take us in viewing the picture?

CIRCUMSTANCES I

In March 1630, Rubens returned home after almost one and a half years of continuous diplomatic travels in Spain and England as the envoy of Isabella, the ruler of the Spanish Netherlands. His seven months sojourn in Spain – where among other painterly tasks he reputedly copied all the many Titians in the Spanish royal collection – was characteristic of the unusual mixture of art and diplomacy that Rubens practiced in these years. Though negotiation with royal patrons was a skill demanded of artists at the time, Rubens's diplomatic responsibilities, conducted under the cover of his artistic activities, were quite unprecedented. It is not only the energy and tact needed to do all of this, but the particular

mixture of the manual skills of the artist with the verbal and social skills of the diplomat that were remarked, not always in complimentary terms, at the time. Rubens's diplomatic aim (probably impossible to achieve) was to bring about a truce between the embattled northern and southern provinces of the Netherlands (Holland and Belgium, as we roughly refer to them) so as to restore economic well-being to his own country, more specifically to the city of Antwerp. (The Dutch in the course of their revolt against Spain had silted up the mouth of Antwerp's Scheldt river, hence effectively blockading the city and destroying it as a port.) By March 1630, Rubens had successfully negotiated a truce between Spain and England which he hoped would be a step in this direction. To cap this public triumph, just before the treaty was proclaimed in December of 1630, Rubens, back in Antwerp, had married his second wife, the young Helena Fourment. I mention these happy events because the *Kermis*, which can be most persuasively dated to sometime in the following year or two, has been generally related to the newly awakened love for Flanders of the diplomat-painter, returning to his home, his new wife, and his art. New-found happiness, on this account, was the occasion for art.[9]

When an internationalist in art and politics like Rubens returns home and paints a picture in the native tradition of his own country there is probably some link to be drawn between his art and his life. But our sense of this link is complicated if we reconstruct the public situation that existed when Rubens returned. There was little to celebrate. Far from producing the anticipated peace, the treaty was negotiated against a background of surprising Dutch military gains with their capture in 1629 of 's Hertogenbosch – ranked by tradition with Antwerp, Brussels, and Louvain as one of the chief towns in Brabant. Philip IV, the king of Spain, hard-pressed economically, refused to help out. He resolved not to give increased military aid to the loyal provinces for the purposes of self-defense, nor to permit them to pursue peace negotiations with the Dutch Republic on their own behalf. In short, Spain would neither give up the idea of victory over Holland nor give the Spanish Netherlands the means to achieve it. So serious was the situation felt to be that, in 1632, some

Flemish nobles staged an uprising against their ruler, and Rubens's trusted employer, the archduchess Isabella.

An event that perhaps brought home to Rubens most immediately the essential and possibly insoluble nature of the differences between Spain and Flanders was the death of Ambrogio Spinola, whom Rubens valued as both friend and patron, which also occurred in the fall of 1630, but half a year after Rubens's return to Antwerp. Rubens had painted his portrait about two years earlier, shortly before Spinola's departure from Flanders for Spain. Born into a great Genoese banking family and now serving as a commander for Spain — for which service he would soon be immortalized by Velázquez as the gracious victor at the surrender of Breda — Spinola represented to Rubens Flanders's best hope for Spanish support for a peace settlement in the Netherlands. So his death in Italy, where he had been forced into exile from the Netherlands and its problems by the Spanish king and his advisor Olivares, must have confirmed Rubens's gloom.[10]

Though Rubens was happy to be home again, his letters after his return speak private joy mixed with concern for the future of Flanders. Early in 1631, a little more than a month after his marriage, Rubens writes an old friend, "I find myself most contented in the conjugal state as well as in the general happiness over the peace with England." He goes on at some length about the delay in payment for his diplomatic service, concluding,

> I am so disgusted with the court that I do not intend to go for some time to Brussels . . . My personal ill-treatment annoys me, and the public evils frighten me. It appears that Spain is willing to give this country as booty to the first occupant, leaving it without money, and without order. I sometimes think I ought to retire with my family to Paris in the services of the Queen Mother [Marie de' Medici] . . . I hope the storm will pass, but up to now, I have not made any decision and I pray the Lord to inspire me to do the best thing.[11]

The *Kermis* was painted, then, not only on the occasion of Rubens's happy homecoming, but also when his concern for the future of Flanders was so great that he thought momentarily of leaving it — though, despite his misgivings about the court, he

thought to throw himself on the mercy of royalty. Ironically, it was Marie de' Medici, not Rubens, who was forced to flee her country six months later to be met at the border by none other than the devoted painter. Rubens's pleas to the Spanish to give asylum to the former French queen, his other great royal patroness, and also (through her mother, Giovanna of Austria) a Habsburg by birth, went unheeded, and she eventually had to continue on to Amsterdam. The *Kermis* is prompted by a deep concern about the state of Flanders. In one sense it is a plea for Flanders.

But why turn to revelry and to peasants if you are in despair about your country? What might these peasant revelers have to do with this background of fact and feeling? It happens that revelry, though not on the part of peasants, plays a role in an undoubted instance of Rubens's pictorial engagement with the state of Flanders – namely the entry decorations that he devised a few years later, in 1635, as Antwerp's formal welcome to the new governor general of Flanders, Cardinal-Infante Ferdinand, the brother of Philip IV. For this kind of occasion painted panels and other decorations on huge wooden structures or stages were set up in the streets and major squares of the city through which the procession was to pass.[12]

The majority of the decorations Rubens designed to greet the new ruler were the requisite glorifications of him and of his lineage, beginning with his just-completed triumph over the Swedish at Nördlingen. But in conclusion, as the culmination to his entry, Ferdinand came upon successive images that, in a different and less expected manner, confronted him with the horrors of war unleashed and the resulting economic devastation of Antwerp. The so-called Stage of Mercury (pl. 18), devoted to Mercury as the protector of trade, appealed to the Spanish governor to bring about a rebirth of Antwerp's maritime commerce and prosperity by showing just how bad things were: in the center, Mercury pirouettes as he leaves the city with the bound and helpless River Scheldt sleeping on his dry urn, the despairing female figure of the city at his feet and the deserted ships of the great harbor behind. To the right of the fleeing Mercury are images of present loss: an unemployed sailor forced to work on

18 Theodoor van Thulden, after Rubens, *Scene of the Departure of Mercury*, from Caspar Gevaerts, *Pompa Introitus Ferdinandi* (Antwerp, 1642).

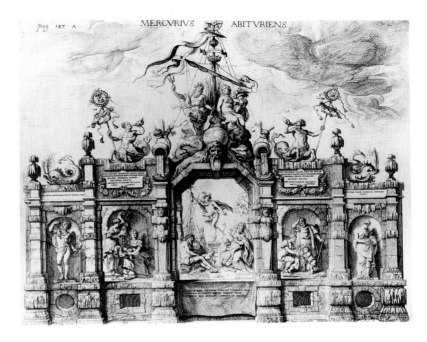

the land turns from his shovel to the figure of Poverty who offers a raw vegetable as the only food for his child, though some future hope rests in Industry, daughter to Poverty, added to her right. While the dismal present is to the right, to the left are images of the bountiful past: Abundance emits gold treasure from a cornucopia held by the figure of Wealth.

Rather surprising in certain respects, and of particular interest to us in connection with the *Kermis*, this prosperity leads to revelry, as represented by the god of revelry, Comus, at the far left. Surprising because, as noted by Caspar Gevaerts or Gevartius, Rubens's close friend, who was the careful and most prudent editor of the original publication of the entry decorations, Comus or revelry, can and, in fact, often does lead to unbridled riot and excess, to dissension and to fighting. Why make a virtue of this? Yet against such a cautionary view, Rubens chose to invoke bacchic energies and revelry as a positive image of Antwerp's prosperous peaceful past despite their problematic, even dangerous or ugly side.[13]

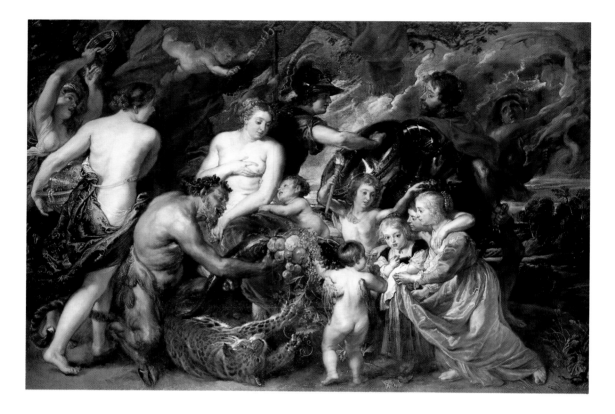

19 *Peace and War*. Oil on panel, 203.5 × 298. National Gallery, London.

This is not the only occasion on which Rubens invoked bacchic revelry as an image of the prosperity of peace versus war. He had done so in the painting known now as *Peace and War* (pl. 19) which he had addressed to the English king on the occasion of the English–Spanish peace treaty negotiated in 1629–30. A fruit-bedecked satyr and two bacchantes with precious objects and a tambourine cavorting on the side of Peace are used to render the benefits and pleasures, literally the fruits and prosperity, of peace. Rubens's figural inventions characteristically display a restlessness more consonant with the activity of making war than with the repose of being at peace. His image of peace is an active one: war is being overcome as Minerva drives away Mars to the right while bacchic revelry follows at the left.[14]

In the context of the continuing war and bad economic times

for Flanders, the *Kermis* serves as an image of peace embodied in the raucous good life enjoyed by the Flemish peasants. In this it is akin to the figures of Comus, and of the satyr and bacchantes. Different though the *Kermis* is in appearance and address from the stage and the painted allegory, it is similar in its concern with Flanders. One might say that, while the entry stage pleads for the city of Antwerp in an elevated, international, allegorical mode, the *Kermis* celebrates the people of the country in the native low-life tradition of the old Bruegel.

Turning from revelry to the revelers, there are economic reasons why Rubens would have used country people to embody his hopes for a flourishing Flanders. There are, in short, economic circumstances about the painting. Though military operations had devastated the countryside in the last decades of the sixteenth century, the evidence is that by 1630 agriculture was flourishing once more. The system of combining intensive planting techniques with rural or cottage industries kept production and employment levels in the countryside up. Flanders was a model of agricultural development for the rest of Europe in the seventeenth century.[15]

If he had so wished, Rubens could have included peasants in his entry decorations. Agricultural stages had been a traditional part of these occasions. They were in place in 1594 and again in 1599 on the occasion of two *joyous entries* for previous rulers – Archduke Ernst and the couple Albert and Isabella. The engravings made to commemorate them suggest that these were rather solemn affairs with prim peasant women and men arranged in neat rows bearing symbols representing their labour and its fruits as a tribute to the productivity of the Flemish countryside (pl. 20). A painting such as Rubens's so-called *Farm at Laeken* (pl. 21), which depicts decorous peasant men and women caring for cows in a glowing landscape beside a wheelbarrow piled high with nature's bounty, is probably intended to give this kind of positive account of agriculture. However, he left peasants out of his designs for the entry because he wanted to concentrate on presenting the central problem facing the new ruler: the failure of Antwerp's maritime commerce. In a sense, then, the *Kermis* not only celebrates the good peasant life, but speaks to realities,

20 *Agriculturae Typus*, from Ioannes Bochius, *Historica Narratio Profectionis* (Antwerp 1602), p. 195.

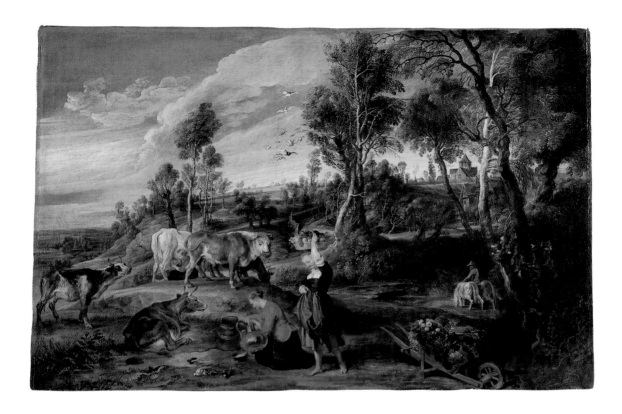

21 *The Farm at Laeken.*
Oil on panel, 81.5 ×
127.5. The Royal
Collection, © 1994 Her
Majesty Queen Elizabeth II.

economic realities, which Rubens strategically chose not to present to Ferdinand.

Rubens was not the first painter to turn to peasant well-being at a time of national despair. Like Bruegel in his paintings of peasant festivities of the 1560s, Rubens was depicting the people who were the economic sustenance of a troubled Flanders. Contrary to his claim that he had retired from politics to paint, Rubens did not put aside diplomatic concerns when he picked up his brush.

In the decades around the mid-century, many people of wealth deserted Antwerp for the country. They transformed themselves into landed aristocrats who replaced the city patricians of the sixteenth century in social stature and economic importance. A few years after painting the *Kermis*, Rubens also took

32

his place in this world of newly ennobled landed gentry. He had laid claim to a patent of nobility from Philip IV in 1624, and he was knighted in 1630 by Charles I. (The honor lives on in England in Bond Street catalogues announcing exhibitions of the works of Sir Peter Paul Rubens or Peter Paul Rubens, Kt.) He confirmed his landed status in 1635 when he purchased the country estate Het Steen and assumed, in addition, the title of Lord of the Manor which came with the property. At the very time that he was warning Ferdinand that Antwerp was dying, Rubens, though still living in and working out of his grand Antwerp house, joined the flight from the city to the country.

Rubens became a seigneur. But to see peasants represented from the seigneurial point of view we must look not to Rubens but to the many *kermis* paintings by David Teniers II (1610–90). While Rubens's peasants vomit, urinate, fall on the table in a drunken sleep and keep company with hogs, Teniers's paintings feature neat and well-dressed peasants who behave decorously enough to be admired, even sometimes joined in dance, by the upper-class observers whose estates grace the horizon (pl. 22). The emphasis on the proprieties and decorum of country society

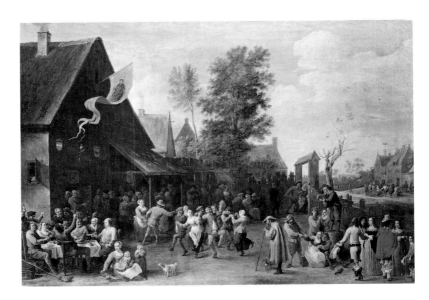

22 David Teniers II, *Peasant Kermis*. Oil on canvas, 76 × 112. Kunsthistorisches Museum, Vienna.

23 David Teniers II, *A View of Het Sterckshof near Antwerp*. Oil on canvas, 82 × 118. National Gallery, London.

accords with the artist's evident anxiety about his own social position. Teniers also wanted ennoblement, but for him, unlike Rubens, it proved a long and consuming battle. Rubens, worried about preserving his independence of the court, refused to move to Brussels as court painter to Albert and Isabella, and bluntly stated his reasons – as man and as painter – for choosing the youthful daughter of a merchant rather than a court lady to be his second wife. Teniers, by contrast, moved to Brussels as court painter, devoted himself in part to a pictorial celebration of the collection of the ruler Leopold William, took a wealthy and socially prominent woman for his second wife, purchased a country estate but a league from Rubens's Steen – and then he had to wait twenty-five years, until 1680, to have his petition for ennoblement granted.[16]

Although Rubens and Teniers share a common interest in rural Flanders, they depict it very differently. Teniers depicts a seigneur (once thought to be the artist), his family, and a servant, prominently lit, before their estate, with a peasant extending the offering of a fish (pl. 23). Rubens, on the other hand, with a degree of playfulness, proposed a series of transformations for his

34

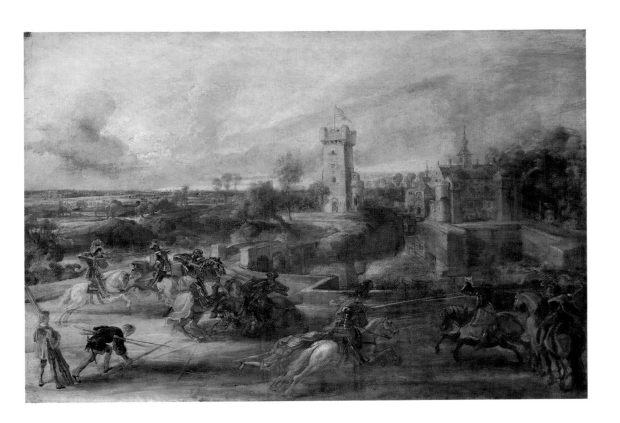

24 *A Tournament before a Castle*. Oil on panel, 72 × 106. Louvre, Paris.

country seat: he depicts its tower as a setting for a medieval joust (pl. 24); or, in the well-known landscape in London, as a country seat with a hardly visible lord overseeing nature's bounty while peasants take a laden cart to market and shoot at birds (pl. 25); and finally, as a surprisingly strife-ridden garden of love where the high-born are behaving as roughly as peasants (pl. 26). And, to return to their respective *kermis* paintings, one might say that in order to convey an image of a harmonious and productive country society suitable for the viewing of a seigneur such as he aspired to be, Teniers expurgated or modified to the point of insignificance the low behavior that was the normal accoutrement of such painted scenes. Rubens, though equally the seigneur, excludes this social consideration from his *Kermis*.

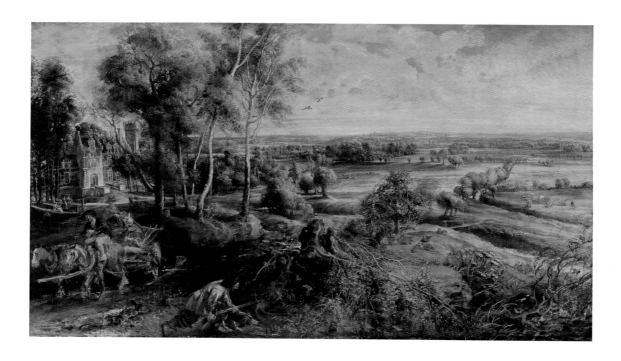

25 *Landscape with View of Het Steen*. Oil on panel, 131 × 229. National Gallery, London.

Though establishing an elevated pictorial position from which to view the varieties of human pleasures displayed by Flemish peasants at their festivities, his *Kermis* does not make his social rank an issue.

My aim has been to suggest the ways in which Rubens's engagement with the situation in Flanders around 1631 helps explain that sense of "locality" that seems so evidently part of the painting. But though Rubens's *Kermis* is born out of and acknowledges particular historical circumstances, it is painted so as to transcend them. Though clearly created in a pictorial tradition going back to Bruegel (and to Nuremberg print-makers before him), it is difficult to name its subject – *kermis* or wedding. What exactly is depicted? Rubens rejects the market-place, sporting events, religious ceremonies, and mandatory saint's banner that usually identify a *kermis*. The wedding crown hung on the tapestry to the left would seem to demonstrate that the title under which the painting was inventoried by Louis XIV – *Les Noces de*

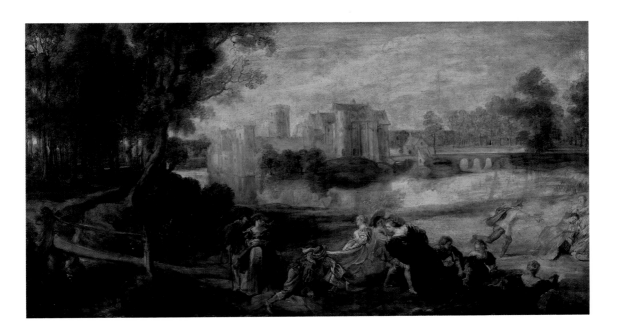

26 *A Château Park.*
Oil on panel, 52 × 97.
Kunsthistorisches Museum,
Vienna.

Village – is correct. A bride, with her hair conspicuously loosened down her back as was the fashion, does appear in one of the preparatory drawings that Rubens made (pl. 28). However, despite the crown against the tapestry (pl. 9), no bride appears in the painting. Rubens, it seems, intentionally left her out. The combination of feasting and dancing seems to derive from certain paired images we find in some sixteenth-century German prints of peasant festivities (pl. 27), but there is no precedent for a wedding being set in such an expansive pastoral landscape. Thus, though drawing on and preserving established motifs from festive scenes such as the vomiting man and his wife, the sleeping man, the pig, and the lusting couples (the prominent suckling mothers seem his addition), Rubens separates his vivid rendering of peasants at their traditional activities from any reference to a particular occasion. Or to put it more positively, Rubens manages to preserve the particularities of peasant behavior and appearance without the particularity of subject.[17]

The absence of any specified occasion contributes to the com-

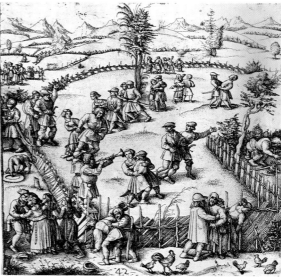

27 Daniel Hopfer,
Kermis. Engraving.
24.4 × 48.6 (two plates).
Graphische Sammlung
Albertina, Vienna.

prehensiveness of the view that Rubens has chosen to present. And the particular flavor given to the comprehensiveness owes something to antiquity – in motif and in text. The dancers' poses convey an elevated flavor. This flavor, a sub–antique one, is confirmed by their reappearance in the pairs of nymphs and satyrs at the left in Rubens's *Worship of Venus* (pl. 30). Our interest is less in which came first (though the evidence seems to give priority to the figures in the *Kermis*) than in the interchangeability of figural poses between representations of the mythic past and the peasant present. Rubens was encouraged in this by the textual tradition. In the world of ancient pastoral poetry, peasants at their celebrations were characteristically joined by satyrs and the nymphs of the place. (The Prado *Peasant Dance* replays this by blending the two in a more elevated manner [pl. 35]). Rubens's reference to this pastoral world is reinforced in the *Kermis* by the landscape setting and distant shepherds who tend their flocks – neither of which had traditionally appeared in the pictorial representation of peasant festivities. The distant church steeple brings us back to the Christian present.[18]

Peasant festivities had their literary antecedents in the poetry of

28 Studies for a *kermis*.
Pen and brown ink over
black chalk, traces of red
chalk, 50.2 × 58.2. British
Museum, London.

Horace's *Odes* and most importantly in the *Georgics* of Virgil. The
look of Rubens's peasants could be described with Horace's
celebrated invocation of dancers who in their rejoicing pound
the ground with their feet – "Nunc est bibendum, nunc pede
libero/pulsanda tellus . . ." ("Now is the time to drink, comrades,
now with unfettered foot to strike the ground") (Horace, *Odes*,
1, 37). And the placing of the feast in the setting of the country
and amidst agricultural life brings it close to the *Georgics* – Virgil's

29 Studies for a dancing couple (verso of pl. 28). Pen and brown ink over black chalk.

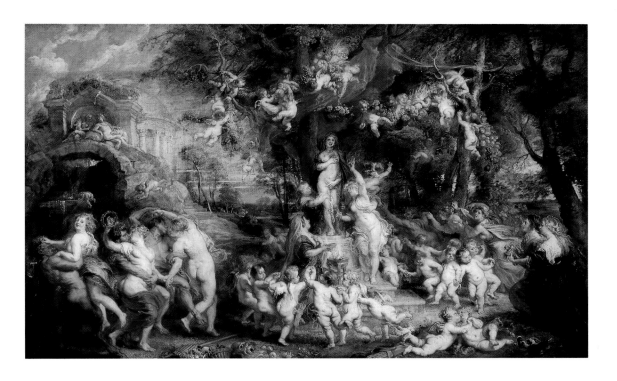

30 *The Worship of Venus.*
Oil on canvas, 217 × 350.
Kunsthistorisches Museum,
Vienna.

fiercely patriotic poem in praise of farming. The poem was
written in the course of the terrible civil wars that raged in Rome
sometime after the assassination of Julius Caesar. In it the
peasant's well-earned respite from labor is contrasted to a world
in which people destroy cities, hoard wealth and drench them-
selves in blood. It had been a time not so different from Rubens's
own. The way in which Rubens depicts the festivity leads away
from the specifics of a Flemish peasant celebration and, by way of
antiquity, to the generic nature of his country's situation. Like
Virgil in the *Georgics*, then, Rubens offers peasant festivity as a
model of a peaceful existence at a time of war.[19]

The lack of specificity as to the occasion and the antique aura
are devices Rubens employs to make his work not a picture of a
kermis or a wedding, but a picture of human festivity embodied
in the representation of festive Flemish peasants. Rubens does not
intend us to separate out his portrait of the Flemish peasants from

31 (following page) Detail
from *The Worship of Venus*
(pl. 30).

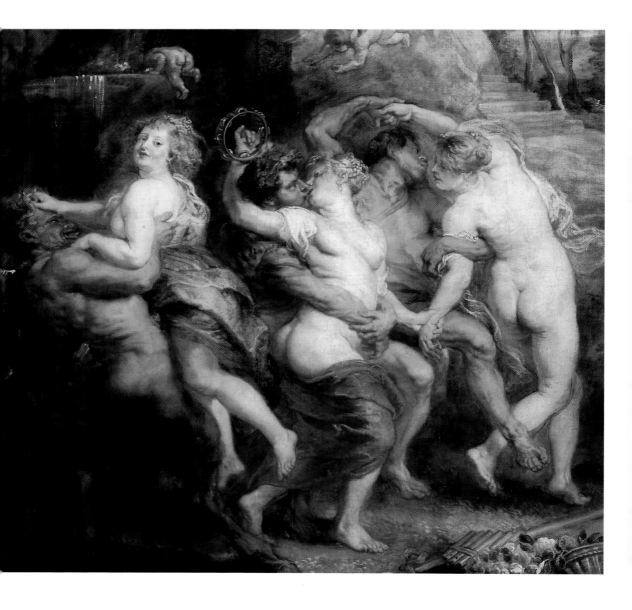

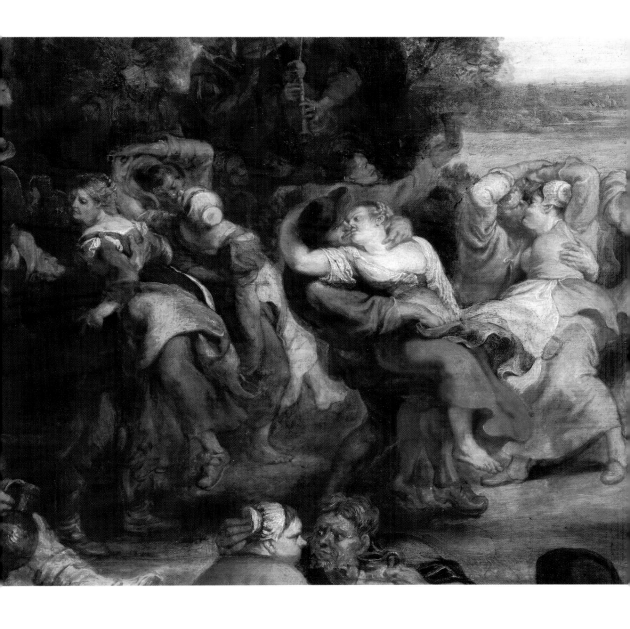

the aspect under which he presents them – so firmly has he tried to bind and so define his view of the state of Flanders and its people to this old, general view of humankind. We have come full circle back to Ruskin and Watteau with whom we began. Rubens, in the *Kermis*, attempted to hold both of their views – the low and the high – without sacrificing either. The manner in which Rubens combines an acknowledgement of present realities (which Ruskin found revolting) with an appeal to a general truth (celebrated by Watteau) is characteristic of his works. In the portrait (in Vienna) of his second wife, Rubens is concerned with beauty rather than festivity (pl. 16). But here, too, the artist works to accommodate the specific, fleshly presence of his wife to a more general view: the folds of flesh at her ribs, her dimpled knees, the loosened wisps of her hair are assembled by Rubens in the evocation of a pose assumed by Venus, the goddess of beauty – a pose that she had long held in art. That is worth noting. For the *Kermis*, like the portrait of his wife, testifies to the particular confidence Rubens had in Art. There is, then, a circumstantial, bound up with what we might call a supra-circumstantial, weight to Rubens's choice and handling of peasant material.

PAINTING II

I was at one time satisfied and ready to rest with this account. There is, however, a problem: it exaggerates certain features of the painting and ignores many others. To concentrate on Flemish peasants turned bacchic dancers is to look at this painting as if it were the so-called *Peasant Dance* (pl. 35). This leaves out what is most puzzling and also what is particularly pleasurable about the painting – or more properly what was puzzling and what was pleasurable to Rubens. One might put it this way: it is a curiously unsatisfactory or unresolved picture which was the occasion for some wonderful painting.

It is so surprising to find Rubens working in this genre that the formal oddities of the painting tend to seem part and parcel of the genre rather than part of his working in it. Let us look again

32 (previous page) Detail from *The Kermis* (pl. 1).

44

at the painting. There is first of all the problem about scale touched on earlier. Scale is something about which Rubens had an uncannily true sense, if by that one means that he could and often did combine figures with a surprising range of sizes and place them convincingly within a single pictorial field. The *Arrival of Marie de' Medici at Marseille* and the *Worship of Venus* can serve as different examples: figures of different type and size are suspended like swimmers in a pictorial medium (pls. 2, 30). And the painting of the *Worship of Venus* – with its several additions – demonstrates the kind of casual ease with which Rubens could multiply figures while expanding his field in different directions.

The *Kermis* is different: seen from a distance – which commentators and publishers alike have tended to avoid – the figures look too small for the clearing before the inn in which they are placed, and the dancers look further dwarfed by the seated drinkers. It is as if different systems – one for setting and one or even two for figures – were uneasily conjoined. The near view and the distant one are separate: close up one sees vital figures emerging in the play of the brush, standing back one sees a multiplication of worm-like beings pressed into a triangular configuration; close up we view the figures straight on, while at a distance we look down on the general array as in the many-figured paintings of the old Bruegel. The difference is that between the close-up view taken by Watteau in his drawing of the dancing couple and the view of the whole array featured in a copy made by Daumier. It is interesting that Daumier closed the gap between figures and space by spreading the figures out at the right and eliminating the empty space beyond.[20]

The problem about scale is related to a problem about space. It is unusual to attend to space as such in a painting by Rubens. Rather than being a prior container, a stage constructed for figures, space is secondary in his paintings. It is unimaginable and unimagined without figures. It is better described as a pictorial field than as pictorial space. Rubens's paintings press such a distinction. But in the *Kermis*, a recession, marked by a clearing that is not quite a path, slices through on a diagonal, pushing the figures to one side and leaving an empty space filled, in the corner, by ducks, a pig, and water.

The difficulties Rubens experienced with the space are trace-
able to what he took as his model – a peasant dance by Adriaen
Brouwer. Brouwer was a contemporary painter specializing in
the peasant genre – though to describe him in such terms does
not do justice to his remarkable art, to his life, or to the legend
that developed about him. We shall be returning to him at
greater length, but for now, it can be noted that a document
testifies to Rubens's 1631 purchase of a Brouwer *boerendans*
which survives today only in a drawn copy in Berlin (pl. 33).
Rubens's inn, the tree, and the still life in the foreground corner
are Brouwer's, as is the overall design. But the Brouwer is more
of a piece than Rubens's paraphrase. Rubens was a master at
pictorial imitation, a master of transforming his mode or proce-
dure into that of another painter while simultaneously adjusting
the model to his own mode. In this case things did not go so
easily or so well.

Rubens's peasants have been looked at as if they were his to
transform by his art. We might instead imagine him as trying to
take something on that was not already pictorially his. He was
not, in other words, transforming vulgar peasants, but trying to

find his way to representing them. Let us modify this now by saying that it was not only a matter of the subject "peasants", it was also a matter of allegiance – what today would be described in terms of a sense of ethnic or national identity. Rubens looked to Brouwer, made use of Brouwer's example, to help him deal with Flemishness as it had been coded in paint.

CIRCUMSTANCES II

In emphasizing the low and vulgar aspects of peasants and describing them with the gusto he does, Rubens focuses on those very aspects of behavior that were considered at the time to be quintessentially Flemish. This native behavior was described and mocked by Ferdinand, the governor general, earlier welcomed to Antwerp by Rubens's civic decorations, in a letter he wrote from Antwerp to the king in Madrid:

> The great festival they call the *kermis* took place here yesterday. It is a long procession with many triumphal carts, it seems to me more beautiful than that in Brussels; and after it has all passed by, then they will eat and drink and get thoroughly drunk, because without that it's not a festival in this country. There's no question that they live like beasts here. [author's translation]

> (Ayer fué la fiesta mayor deste lugar que llaman la caramessa, es una procesion bien larga con muchos carros triunfales, á mi parecer mejor que en Bruselas, y despues que has pasado todo, se van á comer y á bever y para todo en emborracharse, que sin esto no hay fiesta en este pais. Cierto que viven como bestias en esta parte.)[21]

The occasion for Ferdinand's brief letter, dated August 1639, nine months before Rubens's death, was to offer reassurance on the progress of some paintings that had been ordered from the artist, who was disabled by gout. Rubens, painter to the Spanish king, is juxtaposed with, but in no way, of course, related to, the bestial Flemish folk. But in painting his *Kermis*, he associates himself by his subject and manner of painting with that very

behavior. He is not only painting a plea for Flanders but attempting to paint it in Flemish.

Was this, perhaps, a problem for him? And why would it have been? Wasn't he, after all, a Flemish painter? Don't painters have feelings for their countries that are expressed in their art?

When we refer to Rubens as a Flemish painter, it is a classification loosely and amply meant. It is handbook art history of long standing. Though Flanders was the name of only one province, and Antwerp and Brussels were in Brabant, *fiamminghi* as a category had been used to classify painters of the geographic area well before Rubens's time. The Italian historian/critic Vasari uses the term in his *Lives of the Painters* in the 1560s, though Van Mander, the historiographer of northern art publishing in Haarlem in 1604, refers to *Nederlandtsche* and *Hoogduytsche* painters. In the Pelican History of Art series, begun under the editorship of Nikolaus Pevsner in 1953, Rubens is in a volume devoted to Belgian art, although a prefatory Editor's Note admits that this is a geographical term that did not come into being until 1830. During Rubens's lifetime, (the Latin) Belgica, from which the name is derived, continued to refer to the entire Netherlands, north and south, including the rebellious northern provinces commonly referred to today as Holland.

A national name commonly registers the fact that works of art were made by an artist born in a certain place (though the works of *some* emigrés – Antoine Watteau and Willem de Kooning, to instance two – are associated instead with the place where they lived and worked). Unless specifically so marked (as in studies of some French or Russian artists in the twentieth century), it does not refer to the attempt to establish a national art. There is a sense in which it is implicit that works so referred to – as in "Flemish painting," or the commonplace "Rubens is a Flemish painter" – share certain characteristics. We have something in mind when we speak of Dutch seventeenth-century painting, the Russian novel, or the Elizabethan theater. But it does not follow from this that we can say, or even be sure quite what it would mean beyond certain matters of technique to say pictorially or politically (a) that Rubens made Flemish paintings or (b) that he thought of himself as doing so.

Rubens normally painted in what can be described as an international style. (The term has the advantage over terms like "baroque" or "ideal" in that it suggests something about the relationship of the art to public taste.) One could say the same of a Picasso, another man from the provinces who made an inter–national career – though Picasso, by contrast, is the provincial who stuck it out in the international center away from home. It is surprising to be reminded of his Spanishness – that, for example, he spoke French in a Spanish manner. (At the time, of course, this would have been no surprise. Braque has been quoted as remarking, "As was clear later, Picasso is Spanish, I am French; we know all the differences that implies.") Evidence of Picasso's taste for Spanish predecessors, or his use of Spanish motifs, supports an interest in national identity narrowly defined, but it is surely just to think of his paintings as at the center, as helping to create the center, of European art. This is not true of all artists, nor even of all artists who have been considered great. Pieter Bruegel's style, to take an example from Rubens's home territory, could not be described as international. The reach or appeal of art does not depend on being above nationality. Bruegel used his local nationality as a resource. He could, as it were, work through it. But perhaps today, in the midst of respect for local knowledge and voices, it is the claim of the non–local that needs defense: that an art like Rubens's can be humanly relevant and not a manifestation of power exercised over others.[22]

In Rubens's case, his international style might owe something to the composite, complex nature of his roots and the way he coped with this. He was born not in Antwerp, but in Siegen, Westphalia, the son of a lawyer who had been twice exiled: first from Antwerp to Cologne because of his Calvinist sympathies; then from Cologne to Siegen because of his adulterous affair with his employer, Anna of Saxony, wife of Prince William of Orange. From this affair a daughter, Christine von Diez by name, survived and lived on until 1638. Through her, Peter Paul, Jan Rubens's later–born son, was a half–brother once removed to the princes of Orange. Though as far as we know he never made mention of it, there is little doubt that Rubens would have been aware of this early on. An exchange of letters between his father

and John, count of Nassau (William's brother), detailing the Rubens family financial difficulties, was occasioned by the problem of who was responsible for Christine after the death of her mother, Anna of Saxony. The year was 1582, and Rubens was five at the time. Although exiled because of his Calvinism, Jan Rubens could not return to Antwerp, then under the Calvinists, for two reasons: he had once been imprisoned for his adultery by the Calvinist William of Orange and had since converted to Catholicism. Only after his father's death did Rubens's mother, also a Catholic convert, return to the Antwerp that from 1585 was Spanish and Catholic again, where Rubens was brought up from the age of twelve.[23]

Peter Paul Rubens was not a notably early developer as a painter. He established his own manner only in his mid-twenties, when he was living in Italy for almost a decade. The manner stuck. Northern painters offering specialized skills in landscape, portraiture, or the engraving medium were in demand in Italy. And Rubens painted a remarkable series of portraits of the Genoese nobility which was to serve as a principal example for his future assistant, the great portraitist Anthony van Dyck. But almost alone among northern painters – and despite not being a painter of frescoes – Rubens was able to compete for major commissions with, and had the prospect of a successful career among, leading native-trained Italians.

His copies and his collection are ample evidence of Rubens's knowledge of non-Italian art, and the inflection from skills learned in the north is visible in his painting. His continued preference for a wooden (northern) over a canvas (southern) support, and his uncanny ability to combine tonal notions of paint application learned from the Venetians with the northern preference for transparency on a luminous ground made his art truly international or European. It was an internationalized or pan-European version of a generally Italianate high-art style. When he returned to Antwerp, he brought back this exemplary style which, through the products of a large studio, and the design of his own grand house, he hoped to establish in the provinces. It was international in the sense that it was portable, acceptable everywhere: at European courts (Rubens painted for

the duke of Mantua, Marie de' Medici, Philip IV, Charles I, German nobility, and the prince of Orange); by the Church; and by Antwerp merchants as well.[24]

One might also call his style diplomatic: like the language of the diplomat that he himself became in the 1620s, Rubens's style could serve and negotiate between countries and monarchs. Unlike Velázquez, whom he met in 1628 on a diplomatic mission to the court of Philip IV in Madrid, Rubens avoided service as a courtier. (The difference is registered pictorially: compare a serial invention of designs to be carried out with the help of studio assistants proposing the virtues of a ruler and the state, to a dazzling *sprezzatura* performance executed by the artist as if before the eyes of his king. The artist as diplomat invented the Medici series, the artist as courtier executed *Las Meninas*.) Rubens's style was unconnected or undifferentiated nationally, and linguistically neutral. It was the style employed by a man who did not himself have a single or predominant linguistic identity. Rubens usually wrote letters in Italian (which had replaced Latin, which he also knew, as the commonest European language in the second half of the sixteenth century), sometimes in French, rarely in the Spanish of the Brussels court, in Flemish with repeated apologies to his humanist friends and often mixed with Latin. He used Flemish to make quick, informal notes for himself on his drawings, as on the large sheet for the *Kermis*, and certainly also within his own household (as in the surprisingly informal letter he addressed to a favorite pupil/assistant just before he died), but he consistently signed his name Pietro Paulo Rubens, in the Italian form. His identity, individual and also pictorial, was bound to a culture broader than his native place. With the breakdown of Latin Christendom, such a reach was perhaps easier to sustain in paint than in the multiple vernaculars of the newly printed word.[25]

Rubens is commonly praised as working for peace and wanting Netherlandish unity. This is certainly true, but what did this mean to him? He pursued painting and diplomacy within a notion of dynastic Habsburg Europe – truly a Habsburg globe, if we consider the fiefdoms almost-without-end that Philip IV lists as being under his domain in Rubens's patent of ennoblement of 1624:

Philippe, par la grâce de Dieu, roy de Castille, de Léon, d'Arragon, des deux Sicilles, de Hiérusalem, de Portugal, de Navarre, de Grannade, de Tolède, de Valence, de Galice, de Maillorques, de Séville, de Sardaigne, de Corduwe, de Corsique, de Murcie, de Jahen, des Algarbes, d'Algésire, de Gibraltar, des isles de Canarie et des Indes tant orientales qu'occidentales, des isles et terre ferme de la mer océane, archiduc d'Austrice, duc de Bourgogne, de Lothier, de Brabant, de Lembourg, de Flandres, d'Arthois, de Bourgogne, de Tyrol, palatin et de Haynnau, de Hollande, de Zélande, de Namur et de Zutphen, prince de Zwave, marquis de sainct empire de Rome, seigneur de Frieze, de Salins, de Malines, des cités, villes et pays d'Utrecht, d'Overyssel, de Groeninge, et dominateur de Asie et en Affricque . . .[26]

Rubens was willing, in the decorations he designed in 1634–5 for the entry into Antwerp of Ferdinand, the new ruler of the "loyal" provinces and brother to this king, to confront the Spanish with the misery of Antwerp under their rule. But the majority of his pictorial inventions on this occasion celebrated the lineage of the newly appointed ruler. The peace between north and south he was working for, Netherlandish unity as Rubens conceived it – designated by a female figure of Belgica greeting the prince in the central image of the initial Stage of Welcome – was the Netherlands under Habsburgs as successors to the old Burgundian dynastic rule. Burgundy's historic costumes, which he had put together in a book of drawings soon after his return from Italy, served him for the sovereign portraits he designed for the Arch of Philip and the Portico of (Habsburg) Emperors for the entry of 1635. The native heritage for him was Habsburg. It is even suggested that he hung his Habsburg portraits as a gallery in his house. And his allegiance to its previous representative in the person of the archduchess Isabella retained something of the pre-modern character of a feudal bond.[27]

People in the Dutch Republic also thought of the seventeen provinces, north and south, as one. When Constantijn Huygens, man of letters and secretary to the prince of Orange, writing

autobiographical notes in The Hague around 1630, praised Rubens as the Apelles of his age, he couched his praise as a national distinction between us (Belgium, in his Latin, including painters we today call Dutch and Flemish) and them (envious Italian and English collectors). But his Belgium was not conceived of in Rubens's Habsburg terms. As precedent for their rebellion against Spain, historians in the north commonly turned to the ancient Batavians who, in the account of the Roman historian Tacitus, had banded together under Claudius Civilis to rebel against Rome. A juxtaposition of the series of paintings (including one by Rembrandt) commissioned for the Amsterdam town hall and celebrating Civilis's rebellion with the twelve gilded Habsburg emperors Rubens designed for Ferdinand's entry suggests divergent formations and notions of a national past. But we must not forget, in the telling of this complex history, that the inhabitants of the United Provinces – Ollandesi, as Rubens refers to them in his Italian letters – while rebelling against the monarchy in Spain, retained, as they do to this day, a prince from the House of Orange. And it is not surprising that it was to this distant relative that Rubens addressed himself (most certainly in French) on his repeated secret diplomatic journeys to the north on behalf of the archduchess Isabella.[28]

Rubens was challenged about his notion of the Netherlands on the occasion of the extraordinary meeting he requested with Albert Joachimi, the Dutch ambassador in London on 5 March 1630, just before returning home to Antwerp. Serving as a representative of the Spanish throne, Rubens had just succeeded in negotiating the Spanish/English truce that he hoped would lead to peace in the Netherlands. (Joachimi later spoke about the meeting with the English king and his secretary of state Lord Dorchester, whose letter about it I am quoting.) When Rubens told the ambassador that the States (Holland) could make peace if they wanted and, in his reported words, "bring quiett and rest after long warre to all 17 provinces," Joachimi responded by saying that, "there was but one way at this tyme very faysable, by chasing the Spanyards from thence." Rubens is reported to have replied that such a peace (one, in other words, expelling the Spanish, which had, as Rubens acknowledged, been the basis of

the 1576 agreement called the Pacification of Ghent) was "worse than warre." In other words, Rubens put the bond with the ruling Spanish before bond with or unity with the Dutch Republic. (It is conspicuous that, despite the role of the Catholic faith in his life and art, Rubens never mentions it as a bond in matters of war and peace.) In his extensive diplomatic letters that have been preserved, this is one of the few occasions on which Rubens, always working for peace, argues instead the necessity of war.[29]

But the interest of the incident as a registration of Rubens's allegiances doesn't end here. Immediately after the meeting, Joachimi sent his report of it (written in Dutch) not to the prince of Orange, whose friendship Rubens prized, but to the Dutch States-General. Rubens did not win peace on his terms, but he did win another royal patron: one of the last commissions he received, identified as a shepherd seizing a woman in an embrace, and left in the studio when he died in 1640, was ordered by Prince Frederick Henry through his secretary Constantijn Huygens in 1639. And Huygens's letter, proposing a painting with the subject left to the artist's devising, was written to Rubens in French.[30]

Rubens's political stance distinguished and separated him not only from representatives of the Republic, but also from those nobles in the south who, in 1632, in the wake of northern victories on the battle-field, conspired to persuade the archduchess to summon the States-General in Brussels for the first time in three decades to open direct negotiations for peace with the Republic. There was a proposal that all French-speaking (Walloon) provinces might join with France, while Dutch-speaking provinces (Brabant and Flanders) would remain in a United Netherlands. The proposal involved an acknowledgement, unprecedented at the time, of a determining relationship between language and state. It thus threatened Habsburg rule and the Catholic Church, but also a notion of culture.[31]

Rubens's sense of belonging to an international or supranational culture, if no longer Latin at least one containing many languages, is at the heart of his manner of painting. An alternative had been offered: in the previous century, on Rubens's home

ground, the style (working out of a specifically German and Netherlandish print culture) and subject (peasants) of Pieter Bruegel's paintings had turned away from the international manner that his Netherlandish compatriots from Jan Gossart to Antonis Mor to Frans Floris devised with uneven success (pls. 3, 15). On occasion, painters such as Gossart and Quentin Massys had also, it is true, experimented in subject and manner with a retrospective Eyckian mode (pl. 14). But Bruegel's indigenous peasant paintings are confrontational. Their combination of subject and style go beyond the differentiation of the native from the foreign involved in the Van Eyck revival. Bruegel gives a new kind of figural authority to his painted peasants. Kings, when they appear – Nimrod in the *Tower of Babel* (Vienna), or Saul in the *Suicide of Saul* (Vienna) – are diminished. Representative figures (and peasants were repeatedly taken at the time to represent what was Flemish) displace heroic actors.[32]

Circumstances encouraged this. Bruegel painted at a time when Netherlandish rage against their perceived abuse at the hands of the Spanish was building up to an explosion fueled by demands for religious reform. Folkloric studies without a particular political agenda, an early manifestation of national feeling, proliferated. Literature in the vernacular – the coming of the print-language that has so often been essential to a consciousness of nationality – also began to flourish at the time for some of the same reasons. Bruegel made the requisite painter's journey to Italy. But when he returned and painted peasants, he can be said to have chosen to paint in Flemish. A consciously local pictorial culture offered some mixture of distinction from and resistance to what was foreign – the Spanish in armed and taxing presence, and the Italian pictorial style. It is paradoxical that Bruegel came to be collected by the Habsburgs (most of his paintings are to be seen in Vienna), whose rule his paintings in some measure oppose. But he is far from alone among artists in this.

In the hands of those who followed after Bruegel in the seventeenth century – his sons and Teniers in the south, Ostade in the north – vernacular peasants became a genre of painting in its own right. It offered peasants as entertainment, which tended to confirm their place in a pictorial hierarchy (as a lower genre

versus high) and political hierarchy (as lower people versus high). (Seen in this way, even Pieter Bruegel's paintings could be taken as offering reassurance to the rule of his Habsburg collectors.) In the southern provinces, painted peasants offering entertainment went along with a nostalgia for the good old days, the time before Belgica had been threatened with division. Rubens shared this nostalgia – it corresponded with his desire for peace on Habsburg terms. There is an element of it in his decision to paint a Bruegelian peasant *kermis*.

In the Republic, during Rubens's lifetime, literature in the vernacular flourished alongside a continuing humanist Latin culture at Leiden university. Dialects from Brabant and Flanders were the basis for the Dutch literary language used in the northern provinces. But in Antwerp, Flemish as a literary language fell into neglect following the retaking of Antwerp by the Spanish in 1585. (What would Rubens's painting have looked like if his mother had taken him back to a city still successfully leading what we now refer to as the Dutch revolt?) While the older humanist culture, Latinate and Catholic – it had lured the scholar Justus Lipsius back from Leiden and provided Rubens's intellectual circle – flourished, Flemish went back to being the language spoken only by the common people and used for farces (*kluchten*). Language was something of an issue. While Rubens's friend the distinguished antiquarian Sweertius deplored the general lack of love for the Flemish language, it was disdained by some humanists who, reviving an earlier view, referred to it as language fit only for the "kitchen and the tavern." It seems appropriate that the first play (dating from 1635) of Ogier, the only seventeenth-century playwright of note writing in Flemish, was an attack on gluttony.[33]

There is good reason – confirmed again today even as I write – to be fearful of the forms nationalism can take and of policies pursued in its name. Some of the classic modern studies of the phenomenon are antagonistic or worried and a bit defensive. Their strength is structural. Looking backward to analyze the stages in which, and accidents and fictions through which nationalism came to be constructed, they argue against the

nation/state as historically necessary or politically desirable. This follows from considering the default of nationalism to be the nation/state. But the relationship of nation to state is recent. The word *natio* and its derivations in the romance languages came to refer to self-contained groups (guilds or corporations of students, for example) and, by displacement, to a common territory of origin and a common-descent group. Rather than being singular, as the nation-states or those groups arguing identity on its model frequently claim, identity is commonly plural. A person is made up of multiple overlapping, even sometimes conflicting, bits. A sense of belonging can extend to communities born, lived and worked in, languages used in speaking and in writing, kingdoms lived in, cultures shared. An imagined or constructed thing, it is registered in paintings. What are the conditions of identity-making in this sense for a painter and how is nationality registered in painting?[34]

Rubens did not lack a sense of locality. It is registered in his pleas – pictorial and verbal – for the economic reconstitution of Antwerp, and also in those landscape paintings that celebrate versions of his native Brabant and, in his last five years, his newly purchased castle, Het Steen. These represent, respectively, the interests of Rubens the bourgeois city merchant and Rubens the newly titled country nobleman. His earlier landscape paintings, some of them taking up the peasant's lives of Bruegel's *Seasons*, as well as the later ones in a more specifically pastoral mode, register place or locality while avoiding the politics of nationality. It is something landscape painting as a genre could do. But he also had an allegiance that was broader than Flanders, Brabant, or even Belgica: we might describe it as an allegiance to what in our day is called Europe, which for Rubens was loosely represented by Habsburg rule.[35]

The practical problem, then as now, is whether or how such allegiances can work or fit together. (Today one thinks of former West Germans, who want to be European rather than to return to being Deutsch while they live in a nation-state without naturalization statutes, while the French, who permit naturalization and concede some internal regional differences, celebrate being

French.) In his career, as in his paintings, Rubens worked at times and in varying combinations to acknowledge, to relieve himself of, to alter, or to expand upon his local identity.

His *Kermis* is a painting in which, one might put it, a speaker of Italian/Latin attempts to speak in Flemish. Rubens takes up the vernacular with a particular force and avidity. Certain motifs when closely viewed – the vomiting man supported by women, gaping mouths and groping arms and hands – display a vulgarity and a wildness not found in Bruegel, though a version of it had been available to him in the tradition of German prints. The vulgarity brings back, in different pictorial terms, some of the force of Pieter Bruegel's originating paintings.

We know of Rubens's interest in the representation of peasant, or at least common drunkenness and violence from the seventeen paintings he collected by Adriaen Brouwer (pl. 34). (In addition, Rubens owned two of Brouwer's hauntingly lit landscapes.) These small paintings are puzzling because of the pictorial subtlety with which they register and order the violent behavior they so savor. The relationship between their political and aesthetic force is hard to gauge. They are superbly painted works which are combating the nostalgia (and the pictorial casualness) newly characteristic of the peasant genre. Sometime in 1631, Rubens bought a *boerendans*, by Brouwer's testimony the only painting of this subject he ever made. We know only a few tantalizing details of Brouwer's life, which was described as displaying something of the explosive combination of high living and low subject matter which survives in accounts of Caravaggio. But his life evidently had a political side in a different sense. He was born in Flanders about 1605, went north as other southerners had before him and is recorded in 1626–7 in Amsterdam and Haarlem. Unlike so many others, Brouwer was an expatriate, perhaps a *Gastarbeiter* in today's terms, who returned home. It wasn't easy: in 1631, he was in the Antwerp painters' guild and, in 1633, in the citadel of Antwerp where political (presumably anti-Spanish?) prisoners were apparently held.[36]

Rubens was familiar with works of Pieter Bruegel (he owned a number of his paintings and copied a drawing) and with those of his painter sons. In particular, his son, the painter Jan Bruegel,

34 Adriaen Brouwer, *Two Peasants Fighting*. Oil on panel, 35 × 26. Alte Pinakothek, Munich.

was a colleague and friend whose pictorial settings Rubens had occasionally fitted with figures and whose Italian correspondence he had ghostwritten. But with a host of Bruegelian works to choose from, Rubens took Brouwer's *boerendans* as the example of painting in Flemish. Even if he didn't actually help to get Brouwer out of prison, as a story in the early literature goes, Rubens did try to take up his pictorial cause.[37]

★ ★ ★

To sum up: We began looking at the *Kermis* through accounts describing it as a peasant or rustic bacchanal. The suggestion is that Rubens makes art by transforming peasant vulgarity. Turning real life into ideal art is indeed a characteristic Rubens move. A digression into circumstances – Rubens's concern for the state of Flanders and his attempt to relate it to an established notion of the state of man – gave historical weight to this account. Then, returning to the picture, a number of oddities were noted. The suggestion was made that Rubens had experienced difficulties painting in this Flemish format. A circumstantial digression about Rubens's lack of Flemishness in feeling or pictorial mode gave historical weight to this account. Assuming that his international/ diplomatic style made Rubens's entry into pictorial Flemishness difficult, we can now return to the painting to consider once more the pictorial results.

Let us imagine that with the *boerendans* of Brouwer to hand (pl. 33), Rubens begins to plot out a painting – inn to one side, tree springing up roughly in the middle, objects strewn in front, a sharp recession finishing with two tiny churches. It is roughly Brouwer's plan. But he actually begins working with chalk and pen. Back to back on either side of a single very large sheet (more than half a meter each dimension) are two drawings in which Rubens teased out a sense of the peasant goings-on (pls. 28, 29). Figure types and actions are segregated. On one side, peasants collect near diagonal tables, sitting, sleeping, drinking, fainting; on the other, a single pair of dancers spins round and round. Low here, high there – the makings of a peasant bacchanal. But it is more than a matter of segregation by type – these are different drawings. They take the Brouwer up and try it out twice. The peasants are additively disposed, mapped out in diagonal strips following a major and a minor table seen from above. Bits of debris from Brouwer are here and there – the wheel at the lower left, a bit of a barrel, perhaps, above. (Inscribed in Flemish, in Rubens's hand, is an inscrutable note translated as "beggars are lacking . . . and men and women and children." There are also color notations above.) We might suppose Rubens left off with

the group of dancers below, turned the sheet over and ninety degrees to the vertical to pour out sixteen or seventeen variations on a single couple circling together back and forth up the sheet sustaining a passionate kiss.[38]

Before Brouwer's inn an isolated couple is standing in clumsy embrace. Drawing his couple, Rubens takes off from them. The peasants at table materialize, in Rubens's usual inventive practice, out of faint, diagrammatic suggestions in chalk overlayed by definition with pen and ink. But in the dancers, the stages of this inventive sequence merge. In the complexity of line-becoming-limb, and in the self-absorption of the dancing pair, the peasant nature of the bodies is all but left behind. The movement of the chalk taken up by the pen, weaving back and forth three times across the sheet, becomes itself like the repetitions of the dance. One might, too cleverly perhaps, describe the bodies of the couple as drawn into dancing. The aura owes something to the body as Rubens found it represented in ancient sculpture.

In taking up the *kermis* theme, Rubens was committed to painting a multitude of figures at smaller than his usual scale. But there was a virtue to painting figures in a scale only one-half again as large as those in the drawing: Rubens discovered that he could carry the drawing of the figures directly over into painting. The drawn figures are thirteen to sixteen centimeters high, those in the *Kermis* average twenty-five centimeters. (He is working at his more usual size when he recycles the dancers in the Vienna *Worship of Venus* (pl. 30): at about seventy centimeters in height they are four to five times the size of the figures in the drawing.) Perhaps it was this possibility that encouraged Rubens to keep the figures small for the setting. (And perhaps it was after noting their miniaturized appearance on the big *Kermis* panel that he experimented, placing dancing figures of a similar configuration and size on a panel half the height of the *Kermis* to make the *Peasant Dance* in Madrid [pl. 35].)

The remarkable articulation of both the dancers and the drinkers results from a pictorial circumstance that permitted Rubens to experiment with *drawing* in oil paint. He was, of course, accustomed to working in a small-figure format in oil sketches. But his sketches, which served, among other things, as

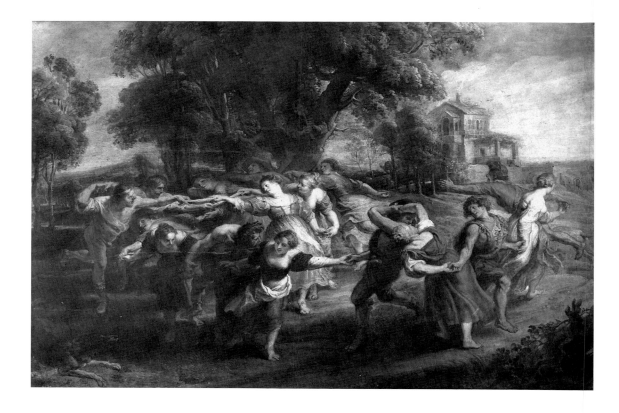

35 *Peasant Dance*. Oil on panel, 73 × 106. Prado, Madrid.

thoughts about a painting, as records for himself or, most frequently, as directions for the workshop, were not the size of nor were they intended as paintings like the *Kermis*. And they do not display its articulation which is close to and continues from that of his drawings in pen and ink (pl. 29). Though the *Kermis* has been described as being *like* a sketch, its genesis, production, and function are different.[39]

We noted that Rubens had problems fitting his painted figures to a spatial format taken from Brouwer. Maybe that is badly put. Maybe he did not really try. If one stands in the Louvre at just beyond arm's length from the panel, the setting becomes peripheral, beyond one's view. One sees only figures which at this distance have all the presence of, but a much greater articulation than, the figures in the large Medici series paintings seen,

as they were originally intended to be, from several meters across a gallery. (Watteau's chalk drawing of the dancing pair represents such a close-up *Kermis* view [pl. 13]. At about twenty centimeters high, his drawn figures are about the same size as Rubens's painted pair.) Perhaps Rubens turned from his drawings to painting the figures and only then filled in the foreground water and farm still life, the middleground inn and the distant hill.

We might borrow a term from Roger de Piles, the great admirer of and propagandist for Rubens in France mentioned earlier and with whom we shall be much concerned in chapter two, to describe the kind of painting activity we are looking at. De Piles proposed the word *liberté* to describe something he specifically noticed about drawings. *Liberté* is not the good composition or design that he termed *Sience* (*sic*), nor the liveliness of the expression that he termed *Esprit*, but the habit of the hand that has learned to explicate promptly and powerfully the idea in the painter's mind:

> La Liberté, n'est autre chose qu'une habitude que la main a contractée pour éxprimer promptement & hardiment l'Idée que le Peintre a dans l'esprit.

It involves comportment, an ease, an absence of bodily constraint. Coming at this from another angle, de Piles makes a distinction between the painter withdrawing *from* himself to finish a painting and giving way *to* himself, abandoning himself as he says, to his drawing:

> Le Peintre qui veut finir un Tableau, tâche de sortir, pour ainsi dire, de luy-même . . . mais un faisant un Dessein, il s'abandonne à son Genie, & se fait voir tel qu'il est.

Liberté then, evokes the draughtsman's relationship to his work in the hand's habit of engaging the play of the mind. It is a human faculty that is visible in drawings.[40]

The discovery Rubens made in painting the *Kermis* was not anticipated. A desire to register something about the condition of Flanders and about his allegiance to it led Rubens to take up the genre of peasant festivity. The difficulties presented in taking up the pictorial format that he had close to hand in a painting of

festive peasants by Brouwer were to a degree balanced by the unexpected opportunity he discovered in the activity of painting as such.

Despite his stated wish to be free of courts, Rubens's confidence in Art is shared by and associated with kings. Despite his repeated criticisms of their misuse of power, his art, one might say, looks to the powerful for support. But his art is also manifest in the skill and energy with which he shapes his medium, in the care with which he works the paint, work that Rubens, on an occasion such as this, leaves remarkably exposed to view. In the *Kermis*, he depicts the pleasure of people abandoning themselves to drinking and to dance. And there is something in Rubens's pleasure in abandoning himself to the working of his paint, his *liberté*, that is like the pleasure of the peasants at their revelry. Considered in this way as a performance, Rubens's art appeals neither to permanence nor to power. It is neither supra-national nor national, neither Habsburg nor Flemish. Rubens establishes his sympathy with ordinary men and women, who are in this case Flemish, in the practice of his painting. This, rather than painting the sun setting on the Flemish countryside, is Rubens's true retirement to self. Perhaps in its self-involvement, an artistic performance such as this necessarily escapes politics.

Making a Taste for Rubens

The first chapter was concerned with a single painting. The aim was to reconstruct Rubens's intentions – the engendering in the sense of the begetting of the *Kermis*. I wanted to see what description I could give of the relationship between the making of a picture and its circumstances. I was not trying to offer a reconstruction of what might have been in Rubens's mind when he started the work, but rather the intentionality of the work itself. Early in the chapter, I introduced Ruskin's view of the *Kermis* as a vulgar scene on the one hand and Watteau's elevated drawing on the other as representing partial and conflicting views that Rubens had been at pains to reconcile. Despite the fact that they post-date the picture, I invoked what Ruskin wrote and what Watteau drew as building blocks in my initial attempt to reconstruct the historical circumstances of the making of the picture.

Now let us return to these materials and take a different tack. Rather than reading these views back into the making of the painting, I want to look at Ruskin's words on and Watteau's drawings after the picture in their own right and consider how Rubens was transformed by the taste of his viewers. I particularly want to call attention to the pattern in which Ruskin's taste – and indeed, as we shall see presently, Watteau's also – presented itself.

Ruskin uses his disgust with Rubens's festive peasants to high-light his delight in another painting of festivity, Nicolas Poussin's *Triumph of Flora*, which in his time hung nearby in the Louvre (pl. 36). Let us read Ruskin once again, this time leading into his comments on Rubens with a bit of his much longer comment on Poussin which preceded them:

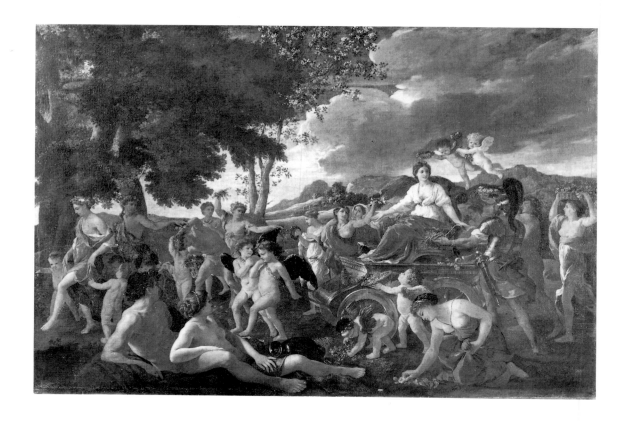

36 Nicolas Poussin, *The Triumph of Flora*. Oil on canvas, 165 × 214. Louvre, Paris.

The Triumph of Flora . . . the trees filling all the blue sky with stars of blossom, and the figures one bright, unrestrainable riot of pure delight – a Keats-like revel of body and soul of most heavenly creatures – limb and raiment, thought and feelings all astir, one laugh of life and of colour . . . Compare with this spirit of pure revelry, true classic – nay, better than true classic – the revel of Rubens, a crowd of peasants near some place, drinking, dancing like baboons, hauling each other by the part of the body where a waist should be, kissing, and – men and women alike – fighting for pots of beer. I never thought Rubens vulgar til today . . . For there is no joy of colour, no fine form, no drollery . . . it is unmitigated brutality . . . I cannot conceive a good man enduring to paint it, bearing the sight

37 *The Kermis.* Oil on panel, 149 × 261. Louvre, Paris.

of his own imaginations. A pig puts its snout out of a stye in the corner, and two ducks, carefully painted, occupy the nearest gutter.[1]

It is in comparison to Poussin's ancient gods and goddesses and their truly classic spirit of revelry that Rubens appears vulgar. It is through the device of differentiating between the two artists that Ruskin couches his characterization and his assessment of each. This pairing, by way of contrasting, the work of Rubens and Poussin was not Ruskin's invention. It had originated in France shortly after the death of both artists in the lectures at the newly founded Academy and in the writings by the art critic and amateur Roger de Piles. It has had a long and productive life.

Distancing ourselves from the individual painting and the circumstances of its production, let us consider art out of art, or painting produced from within a pictorial system. A rococo Rubenism contesting, and in turn contested by, Poussinesque classicism has been a key element in most histories of eighteenth-

century French art. Without disputing the standard history of French painting from 1700 to 1800, I want to offer a different account of the motor, the pictorial motor, that made it run. Of interest is the structural condition that shaped the viewing and making of art. It is less the values inherent in the style of Rubens and that of Poussin, and less the changing taste for each considered independently, but rather the differences perceived at any one time between the two that determined the dialectical structure of the history of art in France well into the nineteenth century. Art out of art, perhaps, but surely not art out of touch with the world. And it was a system of difference between two kinds that came, not surprisingly, to be couched in gender terms. It is of interest that in the eighteenth century, the Rubens mode was, initially, gendered female.

To summarize what lies ahead: we shall begin by considering Watteau's *fêtes* as representing Rubens's paintings as they were seen by de Piles, suggest the basis for this in certain features of de Piles's formulation of a taste for painting, return briefly to Watteau, and, with a few general asides, conclude by proposing an analysis of the history of the French art it engendered to which a view of Rubens was central.

WATTEAU LOOKS AT RUBENS

It was sometime after the turn of the eighteenth century that Watteau copied the central pair of dancing figures from the *Kermis* (pls. 37, 38). He selected one of those couples distinguished by its relatively elevated appearance – relative that is to the rough crowd to the left whose undecorous behavior is set off by a couple such as this one. Watteau's red-chalk drawing not only removes the couple from such low relations, but refines them still further. He does this not only through his handling of the chalk, but also through subtle changes in position and in the description of the figures. The physical exertion of the dance, emphasized by Rubens in the sheer weight of the woman whom the young man so energetically supports, is transformed – despite the rough kiss – into a pattern. The bodily contact is replaced by

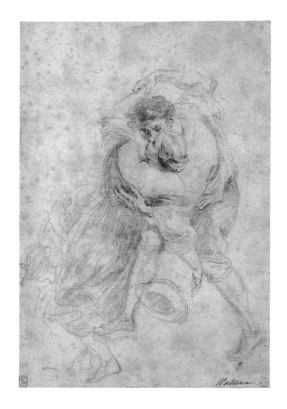

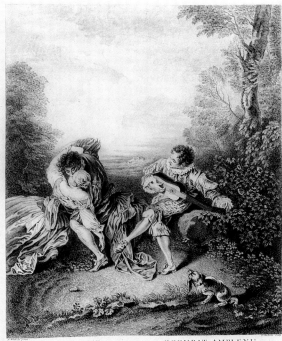

LA SURPRISE .
Gravée d'après le Tableau original peint par Watteau de même grandeur.

OCCUPAT AMPLEXU
Juxta Exemplar ejusdem magnitudinis à Watteavo depictum.

38 (above left) Antoine Watteau, *A Dancing Couple*. Red chalk, 23.3 × 14.7. Musée des Arts Décoratifs, Paris.

39 (above right) B. Audran, after Watteau, *La Surprise*, 1731. Engraving, 31.5 × 41.5. British Museum, London.

a suggestion of fragile social interplay. And it is perhaps not surprising, then, to find them eventually recast into the subtle, somewhat fragile theater of Watteau's *La Surprise* (pl. 39). This title of an engraving by Audran after a lost painting suggests the unexpected awakening of passion rather than the unbridled expression of it we find in Rubens. Watteau confirms this transformation. Embracing on a grassy bank, the couple is now fit company for the music of the courtly guitar rather than the rustic bagpipe, and a dog rather than a pig is the appropriate attendant animal.

Watteau has transformed a motif from Rubens into his own artistic mode. Perhaps Watteau was more interested in certain types of subject rather than others: Rubens's so-called *Garden of Love* (pl. 40), for example, has been said to "anticipate" – the term is an historical awkwardness – Watteau. But the example of

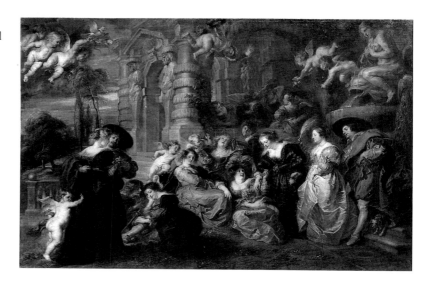

40 *The Garden of Love or Conversatie à la Mode.* Oil on canvas, 198 × 283. Prado, Madrid.

Rubens is a more pervasive element in Watteau's style than an interest in a single work allows. The concentration on the "influence" of this work has obscured the fact that it was a certain (Pilesian) view of Rubens's painting in general that made the *Garden of Love* paradigmatic. Indeed, Watteau's interest in Rubens extended to works of a very different kind: he could turn even the Medici series into a garden of love (or into a *Conversation*, to give the title used to refer to Rubens's picture soon after his death).[2]

Watteau drew after one of the large paintings of Rubens's Medici series which was uniquely available for him to look at and study during the years he lived with Audran at the Luxembourg Palace. Here he would have seen evidence of Rubens's performance as the dominant court painter of his day, producing large works, public in their address, taking up issues of faith, kingship, war and peace with a full panoply of allegorical and mythological figures to carry their sense, engaged with pictorial and literary traditions extending from antiquity to the seventeenth century. Watteau's small, intimate conversations or *fêtes* – works without a subject in the established sense – which he painted for Parisian society are a far cry from these. Yet Watteau's drawing fastens

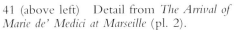

41 (above left) Detail from *The Arrival of Marie de' Medici at Marseille* (pl. 2).

42 (above right) Antoine Watteau, studies after Rubens. Red, black, and white chalk, 19.5 × 25. Private collection, U.S.A.

43 Antoine Watteau, *Fêtes Vénitiennes*. Oil on canvas, 55.9 × 45.7. National Gallery of Scotland, Edinburgh.

onto the central figure of the queen herself disembarking from her boat at Marseille (pls. 41, 42) and then he transforms her into the central female figure of his *Fêtes Vénitiennes* (pl. 43). He transforms the certain step of the queen greeted by her new country into the necessarily tentative pose of a woman in the midst of a dance of courtship.[3]

It was perhaps the question of a woman's self-presentation when she is removed from the rank and actions of a queen that attracted Watteau. But how might we explain this transformation of Rubens's art from a concern with the public affairs of state to the private affairs of social dalliance? It is appropriate to consider Watteau's relationship to Rubens not in terms of how he was influenced by Rubens (as if Rubens did something to Watteau), or how, in individual instances, he put Rubens to use, but rather as a question of seeing. Watteau (not unlike Ruskin, though, of course, with specific pictorial results) saw Rubens with the eyes of someone brought up to see Rubens in his *difference* from Poussin. Someone brought up to see Rubens not as the leading court painter of his time, a learned painter concerned with major public issues even when painting a peasant festival – but primarily as a colorist in Roger de Piles's understanding of that term: one more interested in the way images seduce the eye than in the way they address the mind.

De Piles knew and praised Rubens as a learned man, an accomplished painter of allegories, one steeped in ancient sculpture. But when he urged the shipwrecked French painters, as he referred to them, to spend a day every week for a year in the Medici gallery at the Luxembourg Palace, it was not for these qualities but for what we might describe, adapting his terms, as the coloristic seductiveness of his painting. And it is this that we see when we turn to Watteau whose characteristic works are thematizations of the Rubens implied in the writings of Roger de Piles.

How did this come about? Let us look at the writings of de Piles: why did he take up Rubens and color, and what was the appeal of this to an artist like Watteau?

★ ★ ★

Roger de Piles (1635–1709) was born into a provincial noble family, he studied philosophy, was trained in painting, served as tutor and eventually secretary to a successful diplomat, and, on occasion, under the cover of being an art expert, served as a spy for France in the German lands and in the Netherlands where, imprisoned for four years in the 1690s, he wrote his *Abregé*, or abbreviated lives of the painters. The politics surrounding the institutionalization of the making and collecting of art made a difference to his career. By the 1660s the French government under Louis XIV and Colbert had replaced the painter's Guild of St. Luke with the Académie Royale de Peinture, the state artists' organization which freed the artists from their ancient rules only to bind them to a new master. Part of the organization for state management of art included public lectures or *conférences* on works of art in the royal collection, instituted by Colbert in order to get the *professeurs muets* (as they were disparagingly referred to) to talk. It was the expatriate Poussin, a Frenchman who painted in Rome, whose art was taken by the Academy as its model. In a much-discussed dispute that was born of aesthetic as well as political differences, an opposing camp, defined pre-eminently in the writings of de Piles, rallied instead around the art of Rubens. The interest in Rubens was encouraged by Louis XIV's entry into and victory over the Netherlands – he bought the *Kermis* in 1685 from an heir of the deceased French governor of Breda – as well as by his victory over the duc de Richelieu at a game of tennis. It was at tennis that the king won Richelieu's fine collection of Poussins. And when the duc de Richelieu replaced his lost Poussins with a fine collection of Rubenses, it was de Piles who described the cabinet or, in modern terms, wrote a catalogue for it to which he appended a Life of Rubens based on the recollections of Philip Rubens, the painter's nephew.[4]

De Piles's *Balance* has become notorious: a table, printed at the end of his 1708 *Cours de peinture par principes*, it offers a numerical system for assessing the relative merits of painters. Modern scholars have added up the sums as de Piles himself did not: Rubens awarded 18 for composition, 13 for design, 17 for color and 17

for expression, for a total of 65; Poussin, 15 for composition, 17 for design, 6 for color, 15 for expression, gets 53; Rembrandt, 15 for composition, 6 for design, 17 for colour, 12 for expression, gets 50. Neat and accessible though the table is, it is of distinctly less interest than de Piles's general writing about painting and most particularly his nuanced account of how painting is to be viewed. There are two points here, and they both had an effect on the taste for Rubens. First, in making the distinction Rubens/color, Poussin/design, de Piles contributed the essential elements to a binary structure of taste for art in France. The contrast between a view of Rubens and Poussin effectively divided pictorial taste and practice in France. Second, de Piles's defense of and definition of color as exemplified in the paintings of Rubens gives new emphasis to the viewer's experience of painting, and it does this in eroticized terms.[5]

De Piles published his writings on art over a span of about forty years. They are various in type and address, develop over time, and are not particularly systematic. Questions are left unresolved. But a synoptic view is not unjustified. The education of viewers, in particular the cultivation of a taste for art among French viewers, was the animating force of his writing. This purpose is not unrelated to the fact that for all his interest in painting, de Piles had remarkably little interest in its history. Vasari's *Lives of the Painters*, published in Florence more than a century before, established the model for writing a history of art. But de Piles's *Abrégé*, or abbreviated lives of artists, offers a curiously emptied-out version of this model. He wrote his abbreviated lives, as he notes in his preface, in the interests of painters and others who did not have much time to spend or who, having seen the works, just wanted to refresh their memory.[6]

The first way of making the lives handy for such users was to limit the number of artists by including only those who contributed to the *renouvellement* of painting, or who elevated it to the present state of perfection, or who were included in collectors' cabinets. Despite the Vasari-like references to rebirth and present perfection, de Piles does not share his notion of successive artists working over time to solve the problem of representing the world in pictures. It is true that French painting at the time did

not easily lend itself to a developmental account, but more important than this was the fact that de Piles's understanding of his role as a writer on painting did not lead him to take up such a format. He is more interested in the relationship of picture to beholder than he is in the relationship of artist to artist. On his account, perfection in painting is a matter of definition rather than a matter of achievement. It is a matter of educating taste, not solving problems. One might say that he addressed artists as *viewers* as much as *makers* of pictures. He refashions the artist in the image of the collector/amateur. This was surely part of his attraction for an artist like Watteau.

It is important for his championing of Rubens that, unlike the members of the French Academy and Vasari before them, de Piles also seems to lack a chauvinistic investment in the art of his own country. In a concluding section of the *Abregé* dealing with the "gout des nations," he remarks that French taste is so divided that it is impossible to define. Though de Piles agreed with André Félibien, a contemporary writer on art who was the official historiographer of the Academy, that Poussin was the best French painter and that the best of Italy did not compare with him, he felt no qualms about singling out Rubens as the exemplary artist. De Piles wanted to improve painting as such. We have noted the politics of his championing of Rubens: an outsider to the Academy, his interest in Rubens was encouraged by Louis XIV's victories over the north and over the duc de Richelieu in a game of tennis. But it is also notable that he operated above or outside national politics. By praising the Medici series that had hung relatively unnoticed in the center of Paris since the 1620s, he installed in France a taste for a great foreign painter alongside that of Poussin.[7]

Though de Piles's *Abregé* was written with a mixture of artists and amateurs as its intended readers, amateurs play a large role. In place of Vasari's technical or "how to" section addressed to artists, he includes sections on the idea of the perfect painter, on the interest of drawings and engravings and on what we call the connoisseurship of paintings. These are all directed to the pleasure and needs of the collector. And instead of the inventory of artists' works traditional since Vasari's *Lives*, de Piles offers a

general idea of artists' lives and works and a more extended characterization of the principal ones. The tendency is away from particular instances of accomplishment to general principles of taste. There is no room here for Vasari's finely tuned critical vocabulary. When he takes on the task of describing the paintings by Rubens owned by the duc de Richelieu in his *Conversations*, de Piles employs traditional ekphrastic strategies to which he adds comments that register the exemplary aspects of the use of color/ chiaroscuro in Rubens's compositions.

It has been said rightly that de Piles offers an account of representation that is specific to painting. In other words, he departs from the question of the relationship of the picture to what it represents – as if painting were primarily like a text – to deal with a picture as a picture, as a visual art. His proposals about pictorial composition – which have been called, perhaps too optimistically, his Theory of Art – liberate painting from the dominance of literary assumptions.[8]

It is a virtue of de Piles's writing, as of most complex writing on painting, that painting and the viewing of it are not separate considerations. Nevertheless, his account of painting is effectively split in two parts. Or perhaps it is more just to say that his account of the viewer is split in two: an eye whose attention is seized by what de Piles calls *l'oeconomie du Tout-ensemble* (the unity of the painting as an object replacing the traditional account of the unity of the actions depicted in it); and a person surprised and called into conversation. De Piles could and did illustrate the first point pictorially. The point about the viewer is more elusive and depends on the proof of experience. One could press the difference by saying that the bunch of chiaroscuro grapes that de Piles uses to illustrate the compositional *tout-ensemble* would hardly call a viewer into conversation! We are going to be less concerned here with the picture in view than with his somewhat elusive account of the viewer's experience.

How then, on de Piles's account, does taste for painting take off from notions of color, and what does this have to do with the viewer?

As early as a dialogue entitled *On Color* in 1673, de Piles had put the argument for color single-mindedly and, further, elected

Rubens as the prime exemplar of his view. This was done in contrast to, one might almost say in defiance, of the Academy's established admiration for Poussin and his great predecessor Raphael. In claiming that color was to painting as reason was to man, de Piles specifically sought not that which related painting to the other arts – as *disegno* on Vasari's account linked painting to architecture and to sculpture, or his emphasis on narrative subject linked painting to texts – but that which marked its difference.[9] What distinguishes de Piles from other eighteenth-century writings that discriminate between the arts – the Abbé Du Bos, or Lessing in the *Laocoön* – is that for de Piles it is knowledge of art rather than of literature or drama that is basic.

De Piles defines painting as the imitation of the visible world by means of forms and colors on a flat surface with the aim of fooling the eyes.[10] This was standard. No one in the *disegno* camp would have disagreed with this as a first point, nor did de Piles challenge the importance of *disegno*. The difference between the two camps lay in the relationship between means and ends. De Piles, in effect, reversed the priorities. In his view, what had traditionally been considered the means of art took precedence – as the essential difference that defined painting – over its traditional ends. He combined an emphasis on artifice in painting – the brushwork in Rubens is visible as it is not in Poussin – with the privileging of an appeal to the eye over an appeal to the mind. This produced a definition of the coloristic tradition as concerning itself primarily with the elements and problems of picture-making. And it left to the other camp, to the supporters of Poussin, the more intellectual aspect of painting, which is its address through significant subjects to the mind.

It had been traditional in the literature on art to assume that the experience of color was related to the senses rather than to the mind. It was specifically associated with the mimetic power of art. And for this reason color had negative associations; an appeal to the senses was criticized for being low in the double connotation of appealing to our lesser selves and to the uneducated populace. The notion of color here as elsewhere was invoked equivocally: the populace was accused of liking pretty hues as well as persuasive chiaroscuro effects. We must remind ourselves,

44 Michelangelo Merisi da Caravaggio, *Victorious Amor*. Oil on canvas, 156 × 113. Gemäldegalerie, Berlin.

because it is less obvious, of the latter usage: when, for example, the early seventeenth-century Italian painter Caravaggio was praised for his *colore*, it was not because of pretty hues but because of persuasive chiaroscuro (pl. 44). The ways in which de Piles works this equivocal nature of color/coloring or couleur/coloris (the related terms multiply) have been dealt with by Thomas Puttfarken. We are, however, less concerned here with de Piles's definitions of color than with the new sense of viewing pictures that his privileging of color involved. He overturns the established hierarchy of the mind over the senses and takes the position that the appropriate response to a painting *is* through the senses: its aim is not to convince the viewer's mind or judgment but to overwhelm the viewer through the deception of the eyes: "Puisque la fin de la Peinture, n'est pas tant de convaincre l'esprit que de tromper les yeux."[11]

He agrees with the mimetic assumption that color is what makes objects visible ("sensibles à la veue"),[12] and for this reason he is one of the rare writers on art at the time who not only described Caravaggio in terms of *colore* but praised him for it. But de Piles does not specifically encourage realistic painting such as Caravaggio's works, which are painted so as to lead us to believe, for example, that we see a naked boy before our eyes instead of a painted Amor. De Piles's emphasis is not on the picture as a *trompe l'oeil* – the picture mistaken for the objects it depicts – but on the active fooling or deceiving of the viewer. There is an important distinction here: the phrase he uses is "tromper les yeux." He wants to make sure that it is painting and not painting masquerading as the real thing – like Caravaggio's naked Amor – that seduces us.

De Piles celebrates the effect on the *viewer* of the visible artifice ("o, le beau fard") of the picture.[13] The insistence on "le beau fard" can be understood in the first instance as a way of avoiding the paint-denying (or paint-defying) effect of *trompe l'oeil*. It is curious that De Piles's emphasis on paint is not due to his interest in the production of or even the look of a painting, but to his interest in the experience of the viewer. It is to substantiate this experience that he elaborates the notion of *tromper les yeux* by describing the viewer as seduced, surprised and invited to approach a painting as if called into conversation:

> La veritable Peinture est donc celle que nous appelle (pour ainsi dire) en nous surprenant: & ce n'est que par la force de l'effect qu'elle produit, que nous ne pouvons nous empêcher d'en approcher comme si elle avoit quelque chose à nous dire.

And

> La veritable Peinture doit appeler son spectateur par la force & par la grande verité de son imitation, & que le spectateur surpris doit aller à elle comme pour entrer en conversation avec les figures qu'elle represente.[14]

His attention here is devoted so specifically to the experience of the viewer that it is hard to conceive what pictures that produce such an experience look like. How, or with what picture could

45 Rembrandt van Rijn,
The Kitchen Maid, 1651.
Oil on canvas, 78 × 63.
Nationalmuseum,
Stockholm.

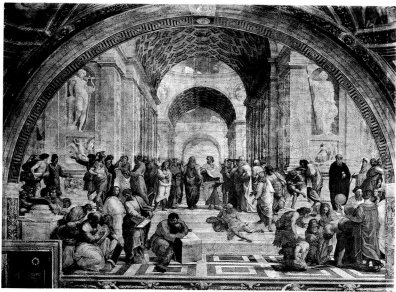

46 Raphael, *The School at
Athens*. Fresco. Stanza della
Segnatura, Vatican Palace,
Rome.

de Piles illustrate that desirable experience of surprise, the invitation to approach as if to enter into a conversation, produced by what he calls the *véritable* painting?

Although Rubens was the artist he championed, de Piles offers the readers of the *Cours* a painting by Rembrandt to illustrate his conversational point. The novelty of the choice underscores the novelty of the argument. Though there was French interest in his etchings (the first catalogue raisonné was published by Gersaint, friend and patron to Watteau, in 1751), and a number of painters imitated him, Rembrandt's paintings did not have an established place in the literature on art of the time. But as Pamphile tells an incredulous Damon in de Piles's *Conversations* of 1677, even the attribution to a known artist cannot guarantee the quality of painting – everything depends on the way a work is experienced.

De Piles had a personal reason for his choice: he himself had bought a painting by Rembrandt (or at least with that attribution) of a servant looking out a door, not because of his judgment of Rembrandt in general, nor because of something he could point to about this portrait in particular, but because of the story told of its intended effect on passers-by in a Dutch street (pl. 45).

> Rembrant, par exemple, se divertit un jour à faire le portrait de sa servante, pour l'exposer à une fenêtre & tromper les yeux des passans. Cela luy réussit . . . Ce n'étoit, comme on peut bien se l'imaginer de Rembrant, ny la beauté du dessein, ny la noblesse des expressions qui avoient produit cet effet.[15]

De Piles continues to put pressure on established notions of taste by contrasting the surprising effect of Rembrandt's painting of the servant on passers-by in Amsterdam to the total lack of effect of an historical scene by Raphael on visitors in Rome. This time the anecdote concerns certain *gens d'esprit* anxious to see Raphael's works, who nevertheless almost walk right by when they finally come upon the frescoes in the Vatican *stanze* (pl. 46). "Où allez-vous si vite?, Monsieur." The reason that they almost walk past is that Raphael fails to surprise them and call them into conversation.[16]

Since conversation is one of the prime models he offers of the relationship between a painting and its viewer, it is fitting that de

Piles first set forth his view of color and Rubens in dialogue form. Vasari tells us that his *Lives* began in evening conversations at Cardinal Farnese's, but the book he wrote is a masterful combination of a number of literary forms — biographical, ekphrastic, rhetorical, technical. In the *Dialogue sur le coloris*, de Piles utilizes the dialogue form as a fiction to recommend conversation as the just response in front of a painting — in this instance, the painting is a copy after a Titian *Bacchanal*. An intimate conversation staged between amateurs is de Piles's alternative to the public *conférences* on the king's pictures instituted by Colbert. Indeed, his fictional *Dialogue* is staged when the two conversationalists leave the Academy after a conference. It is true that the *Cours de peinture par principes* of 1708, which is largely a collection of conferences delivered by de Piles when he had finally been admitted into the Academy, is assembled in a systematic manner. But it is the particular give and take of conversation — emphasizing not the *explication* of a picture but rather the experience of the viewer — that is essential to his mode of thought. The dialogue is an appropriate form for an argument about pictures "calling the viewer into conversation." And it turns on the assumption that the state of being overwhelmed by a picture results in or issues forth in talk.[17]

A whole tradition of French discourse on paintings has its beginning in de Piles and continues in Diderot, Baudelaire, and Barthes. It is more conversation, perhaps, than attentive viewing. This is a very different form of sociability about pictures than the lectures Winckelmann gave to travelers in Rome. Art history as an institutionalized discipline owes more to Winckelmann and has in general been suspicious of the French conversational manner. (The same holds true of museum visitors, between whom there seems to be a division on national grounds. While schoolchildren in the United States, like gallery-goers in Germany, are expected to sit quietly on the floor, listen to a lecture and then learn to answer questions put to them about paintings, schoolchildren in France — Beaubourg is where I witnessed this — are encouraged to start talking among themselves.)

Not every painter took to making paintings with conversation as the end in view. Some French painters have objected. The

stilled, elusive figures that look out at us from Manet's paintings are at least in part designed to stop all the talk.

This brings us to one further point, which makes for perhaps the most compelling distinction between the *conférences* at the Academy and conversations *chez* de Piles: the pervasively erotic aura that his vocabulary lends to the experience of painting. The viewer is surprised or seized, and is called into a conversation. The painting deceives: "tromper," but also "se farder," which is the word used of a woman's make-up. And the eyes of the viewer are seduced: "Il faut donc conclure, que plus la Peinture imite fortement & fidellement la nature, plus elle nous conduit rapidement & directement vers sa fin, qui est de séduire nos yeux."[18]

De Piles, then, encourages a taste for seduction. But it is a seduction that, instead of posing the iconoclastic threat to art of Caravaggio's *Amor Vincit Omnia*, is intended to sustain art. On occasion, de Piles speaks of the painter falling in love with his works and being caressed in return:

> Quoy vous voulez, luy dis-je, que le Peintre traite son Art, comme un amant fait sa maîtresse?
> Ouy, répondit Pamphile, si luy-mesme à son tour en veut estre caressé.[19]

But, in general, he does not make clear to whom or to what – painter, painting, or viewer – man's and woman's roles are assigned. All of this gives a new inflection to the commonplace about painting as the mistress of the painter: instead of empowering the artist as the maker of a desirable work – Galatea brought to life by Pygmalion – de Piles presents painter, painting, and viewer alike as engaged in a social exchange akin to dalliance in the name of love.[20]

De Piles effects an eroticization and in general terms a feminization of the pictorial field akin to what was happening to French society in the *salons*, the other center of conversation at that moment. It has been noted that there was a change in the notion and role of conversation in France at this time. Military metaphors for social interaction were rejected, and the parry and thrust of conversation replaced bearing arms as a symbol of status.

47 *The Coronation of Marie de' Medici*. Oil on canvas, 394 × 727, Louvre, Paris.

As an experience of painting, and as a social practice, the high value placed on conversation was a peculiarly French phenomenon. It roots lay in an aristocratic culture.[21]

WATTEAU AGAIN, BRIEFLY

Eroticized conversation among amateurs returns us to the paintings of Watteau. Watteau's characteristic works with their emphasis on social exchange, on conversations and the aura of love can be described as thematizations of the Rubens implied in the writings of de Piles. De Piles's definition of painting, and specifically of Rubens's paintings, in terms of the artifice, deception, and seduction that draw viewers into a conversation, is realized in the scenes of amorous exchange that constitute Watteau's most characteristic works. And in his *Gersaint's Shopsign* (pl. 50), we witness what can be described as a pictorial performance of that sociable exercise of taste that de Piles encouraged in his conversational writings. Watteau represents the pleasures of looking, conversing, and devoting discriminating attention to the value of art as an erotic exchange. And in supplying a sign for Gersaint's shop on the Pont Notre-Dame, Watteau frankly represents conversation about art as erotic commerce. This is the marketplace for which de Piles in his writings educated the taste of the connoisseurs. Among the paintings on the wall are many that suggest Rubens's mythologies. And there is something poignant about the dog in the right foreground of the *Coronation of Marie de' Medici* from Rubens's Medici series (pl. 48). Transformed from scratching through the affairs of state to scratching through the affairs of art, the dog calls attention to the transformation of Rubens by the hand of Watteau. Himself a Fleming by birth, Watteau marks de Piles's success in inserting Rubens into the tradition of French painting.

If one reads the transcriptions of the *conférences* on paintings in the king's collection that took place at the Academy in the 1660s, one finds a Poussin being constructed there even as de Piles constructed a Rubens in his writings. The seven figures at the left will tell you everything that is written ("escrit") there, Poussin wrote about his *Fall of Manna* (pl. 51).[22] The Academy took his

48 (facing page bottom left) Detail from *The Coronation of Marie de' Medici* (pl. 47).

49 (facing page bottom right) Detail from Watteau, *Gersaint's Shopsign* (pl. 50).

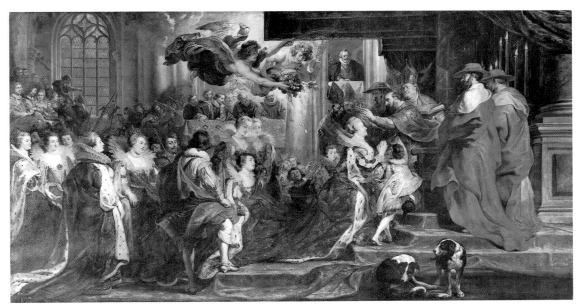

50 Antoine Watteau, *Gersaint's Shopsign*. Oil on canvas, 163 × 306 (originally curved at the top, cut at both sides). Charlottenburg Castle, Berlin.

51 Nicolas Poussin, *The Fall of Manna*. Oil on canvas, 148 × 200. Louvre, Paris.

advice. The characterization of Poussin produced in the lectures delivered at the Academy has had a long life. When Anthony Blunt began his basic monograph on the painter with the surprising remark that he would be treating Poussin not in terms of his "supreme merits as a painter" but as a philosopher-painter, he was heir to the division of painting established in the seventeenth century. As a result, even today it is hard to look at Poussin in different terms — to see that to look at him as a philosopher-painter appealing to the mind, rather than to the eye, is a way of seeing him and not the thing itself.[23]

By Watteau's working lifetime in the early eighteenth century, the division made in painting was no longer a matter of argument. De Piles, once the outsider, had been admitted to the Academy. But nevertheless, the difference established between Rubens and Poussin produced a special taste for Rubens in the eighteenth century. Watteau's interest in the subtle play of colors, his rough or at least unpolished handling of paint, the fragility or artifice of his subjects, the very absence of identifiable, textually based subject matter that was assumed in the tradition of history painting — all of this is related to the representation of Rubens that is owed to de Piles's division of the pictorial field.

PAINTING AFTER DE PILES

The division of painting between Rubens and Poussin effected a curious reversal in eighteenth-century France. Poussin — a relatively unlearned man who painted small domestic works for a bourgeois clientele, concerned with questions of individual rather than with public morality — became the model of the learned, public artist. While Rubens — a learned man steeped in texts, the painter of great public history paintings for church and state — became the model of concern with pictorial practice, even with the artifice of an image.

What I now want to trace is not only the formation of two styles, but the cluster of expressive meanings that become attached to them. Expressiveness in this sense was not at issue for de Piles. Indeed, defending and defining Rubens's style was

52 Nicolas Poussin, *The Death of Eudamidas*, Oil on canvas, 110.5 × 138.8, Statens Museum for Kunst, Copenhagen.

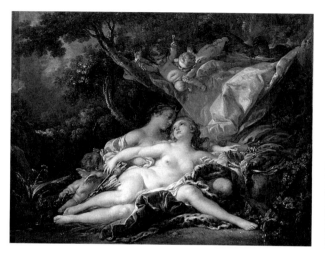

53 (above left) François Boucher, *Jupiter and Callisto*. 1759. Oil on canvas, 56 × 74. The Nelson-Atkins Museum of Art, Kansas City, Purchase: Nelson Trust.

54 (above right) Eustache Le Sueur, *St. Bruno Attending the Death of Raymond Diocrès*. Oil on canvas, 193 × 130. Louvre, Paris.

for him a definition of painting *tout court*. However, when we consider the works of a Watteau successor such as Boucher, the Rubens style isolated in Watteau's painting comes to have specific expressive connotations. We know this from reading its critics – the group of amateurs, writers and collectors of art who existed and published outside of the Academy. To them, Boucher and what came to be known as the rococo style in general was a seductive, easy to look at, feminine, pretty style. "Joli" was a frequent descriptive word. And, indeed, Boucher's brush clothes Jupiter and Callisto – man-disguised-as-woman seducing a woman – in an undifferentiated feminine softness such that the difference male/female pressed by the myth is made to disappear. (For this encounter on Rubens's account, see pl. 114.) This was an art that served the pleasures and satisfied the desires of an aristocratic coterie. It was an art that appealed to a specific

elite. A viewer who saw Boucher this way was Jean–Baptiste de La Curne de Sainte-Palaye (b. 1697), the foremost medievalist of his time who had a general interest in art. He preferred the limited number of figures, limited range of colors, severity and simplicity of Eustache Le Sueur (1616–55) – a newly admired figure at that moment in the Poussin camp (pls. 53, 54).[24]

The expressiveness of style is an issue that has received severe and just criticism in our time. In his essay "Norm and Form," Ernst Gombrich offered an alternative to an historicist analysis of style as the expression of a country or of an age. Styles, he argued, are dependent on each other, on an internal system of comparison which gives them meaning. It is misleading to see Boucher's style as the expression of the ideals of a newly monied class. That is not to say that Gombrich would argue that art does not exist in a cultural context, but rather that what we recognize and nominate as differences between styles is not a matter of differences in expressions. It is a system of what he terms exclusions. Gombrich speaks of exclusions because (good Vasarian that he is!) he assumes that one style, which he refers to as the classical, is the norm for all the others, for those by implication non–classical styles. He instances, among others, gothic, baroque and rococo. In Gombrich's analysis, these are all synonyms for what is perceived to lie outside, to have been excluded from, a classical norm. One could add Rubensian to the list. But I propose to speak of differences rather than of exclusions, because there was no norm, no true resting place in the Rubens/Poussin binary system invoked in the viewing of French art. And the expressive meanings that were perceived as adhering to the members of this binary scheme become an essential part of the making and the viewing of French art. To certain viewers in France at mid–century, the Rubens style seemed feminine, the Poussin masculine.[25]

In 1767, two huge paintings, the *Miracle of St. Geneviève* by G.-F. Doyen and *St. Denis Preaching* by Joseph–Marie Vien, intended as altarpieces for the church of St. Roch in Paris where they still are today, were hung in the Salon side by side (pls. 55, 56). Diderot, among others, took them as alternative modes – all the qualities lacking in one of these artists, he wrote, are present

55 (above left) Gabriel-François Doyen, *The Miracle of St. Geneviève (des Ardents)*, 1767. Oil on canvas, 665 × 393. Saint-Roch, Paris.

56 (above right) Joseph-Marie Vien, *St. Denis Preaching the Faith in France*, 1767. Oil on canvas, 665 × 393. Saint-Roch, Paris.

in the other. It is striking that the difference has nothing to do with invention: the organization of the two works is similar. The distinction that Diderot makes between the discord of one and the harmony in composition and in color of the other is consistent with the established Rubens/Poussin distinction. In another passage written on the same Salon, Diderot points out that the public ("la multitude") was overwhelmed by the Doyen, whereas cognoscenti like himself, despite the Doyen's appeal, preferred the Vien.[26]

The implicit juxtaposition between the popular appeal of one mode and the more select appeal of the other pre-dates the distinction made between Rubens and Poussin. The sense that color and the mimetic appeal an image makes to the *eye* is of a lower and hence more popular nature than the appeal to the *mind* lies deep in our tradition. The curious thing about Watteau and the eighteenth-century Rubens style that followed is that it was a style for the elite that indulged what was perceived as a popular taste for color.

Public painting concerned with great public questions had originally been Rubens's territory rather than Poussin's. (One might contrast the Medici series Rubens painted for a royal palace to the two series of the Seven Sacraments Poussin painted for Cassiano Dal Pozzo and his friend Chantelou.) But a reversal took place. Implicit in the seventeenth-century division of art between Rubens and Poussin, and a result of the succeeding development of the Rubens mode in the eighteenth century, was the assumption that public morality was the particular province of the Poussin mode. And the problem for an artist who wanted to address a large audience in a moral manner might be put as follows: how to make a broad public appeal in the moral (and elitist) Poussin mode. This might have been the problem as Jacques-Louis David construed it.

In the second half of the eighteenth century, to invoke a Poussin rather than a Rubens style signaled to the viewer that the painter was engaged in a male world of significant actions rather than one concerned with the female dalliance of love. In his *Oath of the Horatii* (pl. 57), David relegated the latter to the group of despairing women at the right. But the painting makes claims for a popular appeal not originally anticipated in Poussin's art. It offers a visual immediacy of a sort not displayed by the paintings of Poussin. Commentators at the time wrote that it was as if nature herself ("la nature même") were before one's eyes.[27]

It is in good part in the interest of endowing the Poussin mode with popular appeal that David adds the effect of *coloris*. In a work such as this, David, an artist who was, as we know, in search of a public for his art, takes a lesson, a popular lesson, one might say, from that character and presence that had been attributed to color

57 Jacques-Louis David, *Oath of the Horatii*. Oil on canvas, 330 × 425. Louvre, Paris.

even before de Piles. But the "trompe l'oeil" that David has added here to Poussin is not quite what de Piles had in mind when praising Rubens in terms of "tromper les yeux." Here it is the mimetic and illusionistic effect (one is justifiably reminded of Caravaggio) that had traditionally been associated with color. Within the structure of style as we have seen it, David adds color to the tradition of *disegno*. In connection with David's attempt to make the Poussin mode popular by the addition of color, it is relevant that this was also a characteristic of the taste for Poussin at the time. It is in the second half of the eighteenth century that Poussin's *Death of Eudamidas* (pl. 52), with its striking still-life presence, replaced the *lisible Manna* (pl. 51) as Poussin's most admired work. When Napoleon took an engraving after this depiction of private morality on his Egyptian campaign as a moral exemplum to the French nation, he endorsed the new public appeal of the Poussin mode.[28]

But if we consider a pair of works by David made about 1799–1800, we find that the deployment and hence the meaning of the

two modes has been reversed once again. David invokes the Rubensian mode for the male world of heroic action of *Napoleon Crossing the Alps*, while in his portrait of Madame Recamier, the Poussin mode has become just that – a matter of mode in the sense that we use the term of dress or of beauty (pls. 58, 59). We find Madame Recamier dressed in the style and posed in the décor of the newly uncovered domestic Roman world of Herculaneum. David invokes the color and movement, the concern with pictorial presence and execution of the Rubens mode not to suggest the fragile presence of a society engaged in erotic play, but rather to suggest the energy and fleeting speed of a martial call to heroic deeds. In this pairing, the clear, graceful outlines, local colors and the legible declarative figures of the Poussin mode serve as a definition of and complement to a particular notion of female beauty.

From the seventeenth century on, the evidence is that the fate, or better the force, of these two modes was bound up together, by which I mean that the expressive force of each was seen as changing in relationship to the other. A complete reversal in the expressive effect of the two modes occurred. This is perhaps most powerfully registered in terms of gender. Instead of fixing masculine action, the clear, formal exposition of the Poussin mode,

58 (below left) After Jacques-Louis David, *Napoleon Crossing the Alps*, 1800. Oil on canvas, 259 × 221. Malmaison.

59 (below right) Jacques-Louis David, *Madame Recamier*. Oil on canvas, 173 × 243. Louvre, Paris.

60 (above left) Eugène
Delacroix, *The Massacre
at Chios*. Oil on canvas,
420 × 350. Louvre, Paris.

61 (above right) J.-A.-D.
Ingres, *The Vow of Louis
XIII*. 1824. Oil on canvas.
Cathedral of Notre-Dame,
Montauban.

Madame Recamier sustains a notion of female beauty. And the
coloristic, Rubensian mode, which in the first half of the eight-
eenth century had been seen as devoted to love and women, has
now taken on a masculine tenor in the image of Napoleon.

In 1822, when Delacroix resolved to deal with the most potent
political event of the day – the massacre of the Greek citizens of
the isle of Chios at the hands of the Turks – he invoked the
Rubensian mode. Weight and moral purpose is not represented
by means of the arresting, declarative gestures of the sons of
the Horatii inscribed in the clear contours of the Poussin style,
but with subtle colors, expressive gestures, and abrupt
discordancies. At the very moment that Delacroix spoke, or
painted, to Europe's mourning for the dashed hopes of Greek
liberty, Ingres, in his *Vow of Louis XIII*, used the Poussin (and

Raphael) mode to take a stand for the official state religion supported by the newly restored Bourbon monarch. Both works were featured in the salon of 1824 (pls. 60, 61).

Both paintings are politically engaged, and they represent roughly opposing positions. But the stylistic mode adopted by each artist does not in itself express or reflect – to use the verbs sometimes misleadingly employed for this point – their respective positions. To argue, for example, that "the strict hierarchical relationship between King and Virgin suggests the rigid dogmas and calculated faith of official Catholicism" falls into the expressive fallacy about which Gombrich has rightly warned us.[29] In the seventeenth century, Rubens had represented a staunch defence of Catholic church and state in the mode that is here taken up by Delacroix. Ingres could trust that his painting would be seen this way in 1824 because it would be seen in contrast to the Rubensian mode as taken up in the anti-authoritarian *Chios* by Delacroix.

In plotting Watteau, Rubens, the rococo, and then David, Poussin, and neo-classicism, we have been following a well-worn path through eighteenth-century French art. What distinguishes the present account is that the expressive force attributed to these two modes or styles is seen as less dependent on the inherent nature of either one, than on the structure or pattern of difference established between them as it was first articulated by de Piles.

The difference Rubens/Poussin is only a way of seeing; it is, in a sense, arbitrary. For indeed, there are similarities between the works of the two painters – some Poussin mythologies, for example, are Rubensian and vice versa. A painting such as the *Venus and Adonis* in Fort Worth attributed to Poussin could also be described as looking a bit like Rubens (pl. 62). But seeing the difference between the two proved fruitful for the French painters who worked with it. Indeed, it was almost necessary for painters to make the discrimination at the time. Those who did not found themselves in a pictorial muddle; they occupied a kind of pictorial no man's land. Great numbers of eighteenth-century mythological works – paintings oozing with flesh, bodies converging with other bodies and with assorted bits of fabric and

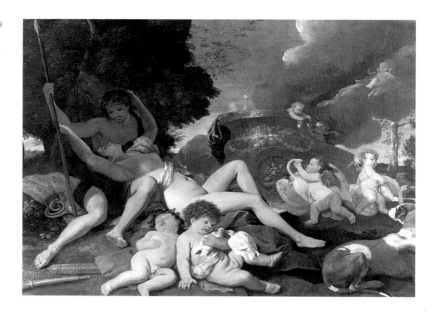

62 Nicolas Poussin, *Venus and Adonis*. Oil on canvas, 98.5 × 134.6. Kimbell Art Museum, Fort Worth.

greenery suggesting the experience of pleasures untold – are the result. Such painters were undiscriminating.[30]

Let us stop to consider where this all leads – both forward in time and then back to de Piles. In arguing that it is not qualities inherent in these two styles, but the difference between them that constitutes their meanings at any point in time, I have been arguing in a manner that is intentionally similar to Saussure's proposal about the nature of language. Saussure's contribution to the study of language lay in his rejection of the substantive view in favor of a relational one: language, he argued, should not be studied only in terms of its individual parts, nor only diachronically, but also in terms of the relationship between those parts as constituting a unified field, as a self-sufficient system. It is not necessary to demonstrate the relevance of this type of analytic mode to pictures since that was already done, almost contemporaneously with Saussure, by Heinrich Wölfflin in his *Principles of Art History*.[31]

In American classrooms and textbooks, it was once a commonplace to think of Wölfflin as the father of formal analysis –

that tracing of diagonals or triangles that teachers of introductory and even advanced courses in the history of art once claimed to find in paintings. And it was also common to think of Wölfflin as an historian of style. As an historian of style, he was once perceived to have been at fault because he simplified or skipped over steps (where is mannerism on his account?) in the historical sequence. When style and formal analysis are out of fashion, Wölfflin is not much on people's mind. But it is salutary to remember that we owe our lasting habit of double-slide projection to Wölfflin – that is, the peculiar technique native to the art historian which amounts to seeing and describing each work of art in terms of its difference from another.

Wölfflin, among other things, was both an exemplary analyst of pictorial forms and the father of art-historical structuralism.[32] The relationship between these achievements is a complex one. He proposes a set of bipolar oppositions that constitutes a system or language – line/color, closed/open, planarity/recession, unity/multiplicity, clear/indistinct. It is a system like that which was established in the Rubens/Poussin opposition with which we have been concerned. And in such a system, as we have amply seen, meaning or pictorial effect does not arise, is not perceived in individual elements – color as such can give rise to many different effects – but in a system of differences as in color versus line, or Rubens versus Poussin.

An interest of the disagreement between *Rubenistes* and *Poussinistes* is that it isolated that elemental pair of properties – color and design – that had been considered basic elements of painting in the west since antiquity. The distinction is not made in all pictorial traditions. But to this day, art students in the west are taught form and drawing on the one hand and color on the other. Recent studies of the brain even suggest a physical basis for this, since it seems that the perception of forms and their outlines is handled by a different part of the brain from the perception of colors. Neither the practice of Rubens nor that of Poussin was as specialized as were the claims of those spokesmen who represented them. But de Piles single-mindedly pursued the implications of color experienced quite separately from other aspects of a painting. And he proposed that Rubens, in contrast to

Poussin, should be seen as offering that experience. And, at least as I see it, the curious thing happened that, in the guise of Rubens and Poussin, these two pictorial elements – a bit rudely pulled apart one from another – were fashioned by artists into the basic structural elements constituting the dialectic history of French art.

Whether Matisse and Picasso were still working within this system of difference, or can only be seen as having done so, is a matter of critical judgment.

Chapter 3

Creativity in the Flesh: The *Drunken Silenus*

It is in the nature of the argument so far that it has skirted the issue of the propriety of the eighteenth century seeing the Rubens style in a feminine mode. As a public figure, painter to kings, clerics and merchants, whose pictorial inventions manifest a remarkable intellectual, even scholarly prowess, and, more blatantly, renowned as a pictorial celebrator of fleshy women, Rubens might seem to exemplify the artist as male in the tradition. The difference between Rubens (female) and Poussin (male) is, after all, just two versions of the male view.

It is such thoughts that led me back to consider what Rubens's own sense of identity and gender as an artist might have been. Circumstantial studies have tended to concentrate on the artist as the viewer of his/her art or as the maker of a work to be viewed. It is for this reason that the study of circumstances and of reception have fitted together so easily. Much attention is paid to how paintings have been seen. The pressure is outward from the work. But there is another account which has to do less with how the viewer is served, than with the satisfactions of the maker. The pressure is inward, on the artist in the making.

The question might be put: how did Rubens embody himself in his painting? Unlike other painters at the time – Vermeer, Velázquez, Rembrandt and Poussin to name the four most prominent in this regard – Rubens never painted himself as a painter, in the workplace or with the tools of his trade. Not home, nor court, nor studio, nor allegory of it is represented as the site of his practice. For all the brilliant efficiency of Rubens's studio factory – which, on occasion, expanded to make use of studios all over Antwerp in order to make visible

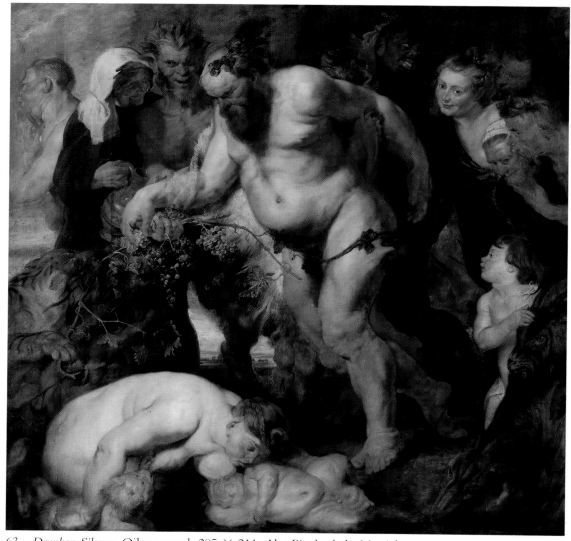

63 *Drunken Silenus*. Oil on panel, 205 × 211. Alte Pinakothek, Munich.

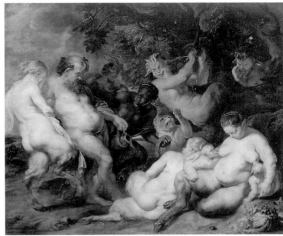

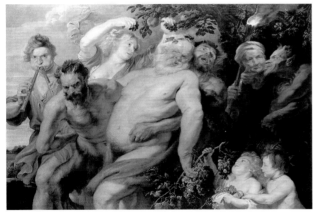

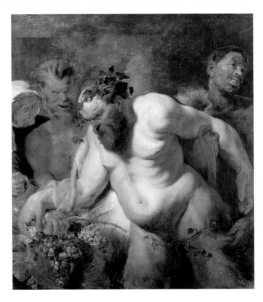

66 (above) Workshop of Rubens, *Drunken Silenus*. Oil on canvas, 133.5 × 197. National Gallery, London.

64 (top left) *Drunken Silenus* (or Hercules). Chalk reinforced with pen. 27 × 30 (left part of larger sheet). Musée Condé, Chantilly.

65 (top right) *Bacchanal*. Oil on canvas transferred from wood, 91 × 107. Formerly Hermitage, St. Petersburg, moved to Pushkin Museum, Moscow in 1930.

67 (above right) Workshop of Rubens, *Drunken Silenus*. Oil on panel, 139 × 119. Gemäldegalerie Alte Meister, Schloss Wilhelmshöhe, Kassel.

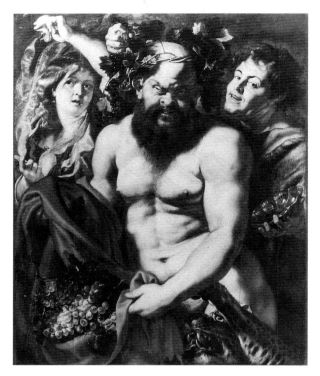

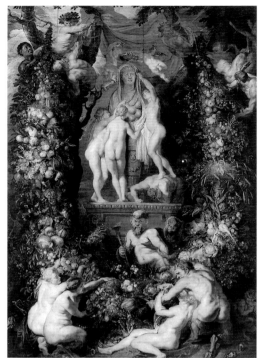

68 *Drunken Silenus*. Oil
on panel, 118 × 98.
Palazzo Durazzo-Pallavicini,
Genoa.

69 Rubens and Jan
Bruegel, *Nature Adorned by
the Graces*. Oil on panel,
106.7 × 72.4. Glasgow
City Museums: Art Gallery
and Museum, Kelvingrove.

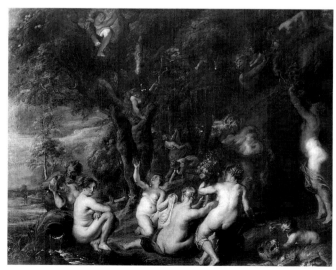

70 *Nymphs and Satyrs*. Oil
on canvas, 136 × 165.
Prado, Madrid.

71 *The Triumph of Bacchus*. Oil sketch on wood, 26 × 41. Boymans-van Beuningen Museum, Rotterdam.

72 *Bacchanal*. Oil on wood, 128 × 140. Palazzo Bianco, Genoa. (Before restoration.)

the establishment ideologies of Europe – he seems to have imagined his site of making elsewhere, stranger, wilder, less social, in the body and, by extension, out of the mind. And if there is a single figure to whom he gave particular weight, with whom I think he signals kinship, it is the fleshy, drunken Silenus (pl. 63). Silenus is no woman, of course, but neither is he in any condition to make either love or war (to offer the Renaissance alternatives for men). Yet he is empowered or creative in the sense that, when drunken and bound, he abandons himself to his song. This was a great part of his appeal to Rubens. This is Silenus according to the Roman poet Virgil.

Silenus was not a notable figure. Even a summary account risks making him seem more important than he was, thus blunting the idiosyncracy of Rubens's focus and fixation. In the bacchic world, he was secondary to Bacchus. His nature was elusive and contradictory: parentage unknown; part man, part beast; always old or middle-aged; a follower of Bacchus's troop, in time claimed to be his teacher; a comic figure riding an unmanageable, braying ass, failing in amorous pursuits, and bitten by bees; but also a truth-sayer, on some accounts, when bound with peasants' wreaths and brought to King Midas, and a poet when bound up by two shepherds and a nymph in Virgil's sixth Eclogue. (The relationship between bondage and creating would surely not have been lost on Rubens, who was also bound, though by chains of gold instead of wreaths, in the service of kings.)[1]

Rubens painted and drew Silenus a surprising number of times. His involvement started early, and it persisted. Among the images are: an early drawing and painting attributed to him after Mantegna's print of the *Triumph of Silenus* (pls. 73, 74); a drawing after an Annibale Carracci engraving of Silenus (pl. 75); a so-called *Dream of Silenus* (pl. 76); a small *Bacchanal* formerly in St. Petersburg (pl. 65) which was developed in a jovial direction ("une yvresse gaye," de Piles wrote) in a workshop picture now in London (pl. 66), and in a more somber direction ("yvresse melancolique") in Rubens's painting now in Munich (pl. 63); the Munich *Silenus* was also preceded by two half-length images – a smaller painting beneath and within it preserved in a copy in Kassel (pl. 67), and a separate, frontally viewed image in Genoa

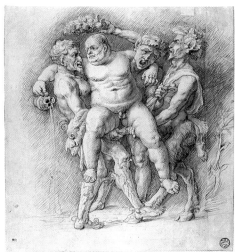

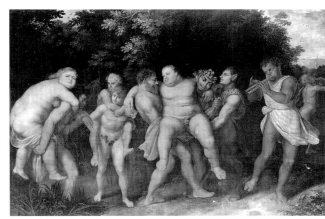

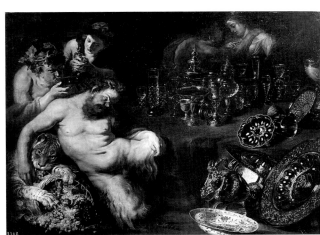

which, as was suggested long ago, depicts Silenus presented to the people on the model of the mocking of Christ (pl. 68); Silenus – accompanied as in Kassel and Munich by a black celebrant – is a secondary figure in a painting of *Nature Adorned by the Graces* in Glasgow (pl. 69), and in an Ovidian scene of nymphs and satyrs (pl. 70); he tags along behind, riding his ass in the *Triumph of Bacchus*, one of the Ovidian works designed for the Torre de la Parada (pl. 71), a hunting lodge of Philip IV of Spain, one of Rubens's last major commissions. If we doubt his own relationship to all of this, there is a curious portrait (once imaginatively called the "Family of Rubens," perhaps because the hero's face, and also that of a satyr beside him, resembles the artist) of a warrior disarmed by love and wine in a bacchanalian company (pl. 72). A bust of Silenus decorated the garden court of his Antwerp house. There is, finally, in addition, an impressive group of Silenus-related drawings: after the antique, after life, as well as the two directly taking up Virgil's Eclogue (pls. 81–3, 85–6, 110, 112).[2]

It is Virgil who makes Silenus a central figure for the making of art. In his sixth Eclogue of *c*.30 BC, two shepherds (Servius in his commentary calls them satyrs/fauns) and a nymph called Aegle come upon Silenus drunk as usual and asleep. Binding him up with wreaths and, with the help of the nymph, smearing his forehead with the juice of berries, they wake him and make him sing. And this low figure, in his drunken, bound state, pours out mythic tales of creation, of love, and of death. (It is a nice coincidence, given his engagement with Silenus, that Rubens painted a number of the very myths of which Silenus sang as part of his series of designs for mythological paintings for the Torre de la Parada.) The narratively first of two drawings Rubens made after Virgil represents the binding-down as an aggressive, even a violent, action (pl. 110). Ferocity characterizes the action depicted as well as the manner of drawing. Pressed to his knees, arms twisted behind, head – with face twice drawn – forced back, vulnerable flesh exposed, Silenus is depicted as overcome by a gesticulating grinning satyr squeezing juice upon his brow, and a nymph. Virgil's word for their action is "adgressi," and the drawing rivals it. The second, necessarily more elusive drawing,

77 After Jusepe de Ribera, *Drunken Silenus*. 1628. Etching.

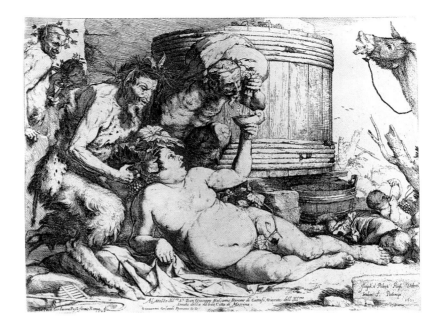

might be described as registering the creative outpouring that follows (pl. 112). Identification of the narrative actions, however, does not begin to do justice to the quality of Rubens's engagement.[3]

But the major evidence of Rubens's engagement with Silenus is the painting now in Munich known as the *Drunken Silenus* (pl. 63). As a painting, it is exceptional: it is directly related to no text and is only loosely related to other images − mostly, in fact, to Rubens's own. There was no pictorial precedent for devoting an image like this one to the mythical figure who was marginal, middle-aged, drunken and mocked. (The only other monumental painting of Silenus is Ribera's most undignified drunkard − a work, it is interesting to note, given that drinking is its theme, that was commissioned in 1626 by a Flemish merchant living in Naples [pl. 77].) A naked body of great and fleshy bulk is at the center of a large (2 × 2 m.) panel surrounded by performed examples of the sexuality and nurturing of man, and of beast, as well as of creatures between the two, and by the ages, social

78 *Drunken Silenus*. Oil
on panel. 205 × 211. Alte
Pinakothek, Munich.

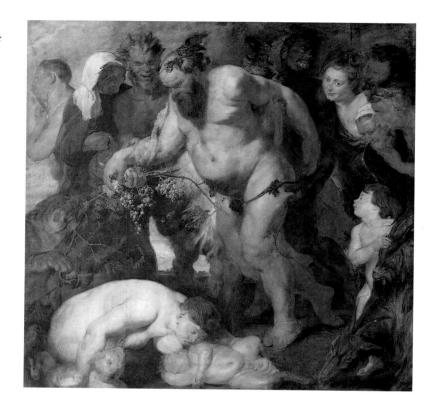

79 Workshop of Rubens,
Drunken Silenus. Oil on
panel, 139 × 119.
Gemäldegalerie Alte
Meister, Schloss
Wilhelmshöhe, Kassel.

orders and colors even of humankind. Standing before the
picture, we are situated with our eyes at about the level of his
knees. The massive, naked figure looms, unsteadily, over us. But
though he is pictorially dominant, Silenus is not dominating.
Quite the contrary. He leans forward, head slumped in a stupor,
his right arm extended only with assistance, while the left one is
gripped by the hand of a black man who simultaneously pinches
the ample flesh of Silenus's thigh and follows so close as to appear
to be penetrating the huge body from behind.[4]

Rubens started working on the picture in the 1610s, when he
was in his mid-thirties. The first stage, half length and with fewer
figures, is preserved in a studio copy now in Kassel (pl. 79). He
added to this by literally expanding it twice, in his characteristic
manner. Silenus became what might more properly be described

110

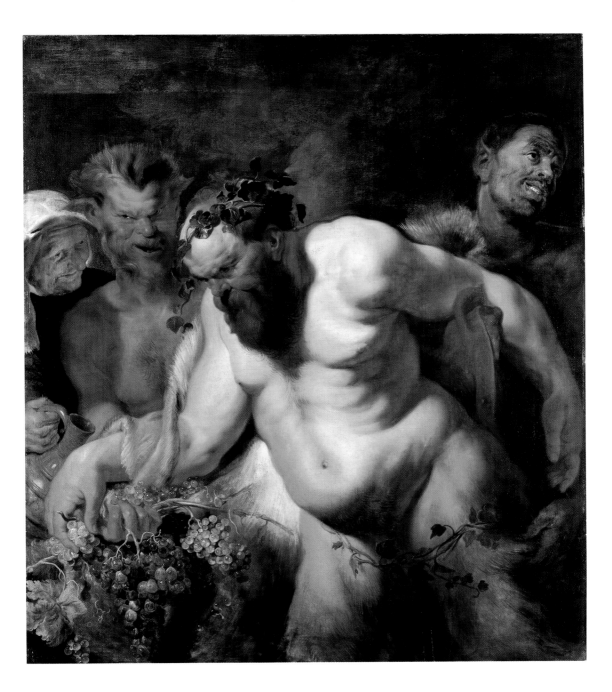

as the Procession or even the Triumph, if the word is applicable, of the Drunken Silenus. Rubens held on to the painting. It is recorded in the inventory of his possessions made after his death in 1640. The *Silenus* had special significance for him.[5]

When it was one of the three Rubens bacchanals owned by the duc de Richelieu, de Piles astutely described Silenus's drunkenness as melancholic ("yvresse melancolique") and noted that his followers are "toutes occupées à se mocquer de luy." He also sensed and paid tribute to the great pictorial ambition Rubens displayed in the painting of this fat, drunken, mocked man: "Je suis persuadé que dans cet Ouvrage Rubens a voulu porter la Peinture au plus haut degré qu'elle puisse monter: tout y est plein de vie, d'un dessein correct, d'une suavité et d'une force tout ensemble extraordinaire."[6]

Yes, but why?

Silenus according to Virgil is not depicted here, at least not directly. The painting is the major pictorial evidence of what was for Rubens a pervasive concern. Part of the appeal for Rubens must have been that Silenus was frequently depicted in antique images. He was present in images much more than in texts. Silenus was therefore perceivable directly by the senses rather than only in the imagination, to call on the corrective distinction with which Rubens replied to Franciscus Junius upon receiving a copy of his *De Pictura Veterum*, a compilation of the lost art of the ancients based only on texts. He drew a standing marble Silenus now in Dresden twice over, as was his practice in studying antique statues, from different angles (pls. 81, 82). Presumably also when in Rome, he drew the portion of the frieze on a famous vase depicting a supported Silenus stumbling forward (pl. 83), and also some Silenus heads.[7]

My sense is that Rubens's notion of Silenus results from informing the body of the fleshy bacchic figure he found in art with the account of Silenus as ecstatic/Orphic poet he found in reading Virgil. This suggested to him a physical embodiment of an abandonment to making/creating with which he could confront the condition of the poet/maker, and specifically the condition of men as makers.[8]

Rubens's Silenus is part of a larger bacchanalian interest.

80 *Drunken Silenus with Tankard.* Marble. 103 high. Skulpturensammlung, Dresden.

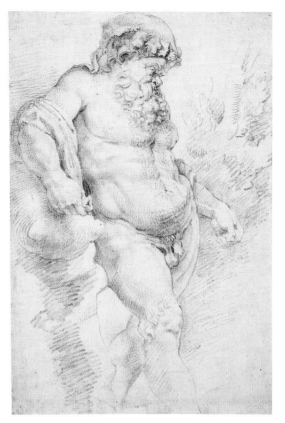

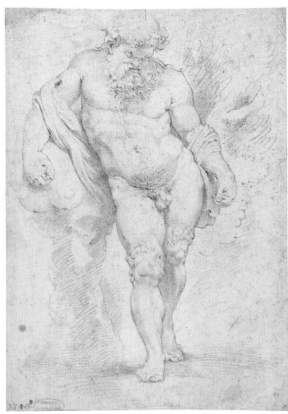

81 (above left) *Silenus* (from the side), after an antique marble. Black chalk, 41.3 × 26.2. British Museum, London.

82 (above right) *Silenus* (from the front), after an antique marble. Black chalk, Musée des Beaux-Arts, Orléans.

83 *Silenus*, after the frieze of the Borghese Vase. Black chalk, 29.2 × 38.3. Kupferstichkabinett, Dresden.

Rubens was a notably moderate man in his habits. He placed a Stoic motto praising moderation, a sound mind in a healthy body, on the wall of his Antwerp house, and his nephew reported to de Piles that he did not like excessive drinking. All the more interesting, then, that his art and that of his studio abounds in vivid, often coarse, festive and bacchic imaginings which seem to be offered neither in criticism nor with contempt. Not only the festive peasants, but satyrs chasing or carousing with nymphs, Hercules become Bacchus-like in his drunkenness, and, most impressive of all, the great Silenus lurching forward in a drunken stupor.[9]

We have already seen something of the positive notions that such images engaged. Rubens invokes bacchanalian figures on the side of Peace in the painting of *Peace and War* completed in England in 1629 (pl. 19). The festive peasants in the *Kermis* which Ruskin found so vulgar offer an established, indeed an ancient (georgic) image of peasants' pleasurable respite from labor, implicitly contrasted to the horrors of war. It is less a satire on drunkenness, than a celebration of the circumstances that make it permissible. Rubens depicts the pleasure of people abandoning themselves in their dancing. And this is akin to another kind of abandon – his nude wife, having bathed, taking pleasure in her naked flesh (pl. 16). His sympathy with these, as it were, low or ordinary figures (peasant and beloved young wife) released and at their pleasures, is visible in the manner of his pictorial handling, the delight he displays in his working of the paint. It is not surprising that a few months before his death, Rubens defended his slowness to complete a painting by writing that he wanted time to be able to do it with pleasure. This can be described as an exercise of *liberté*, to use the Pilesian term introduced at the end of the previous chapter. As a partial answer to the question of why he put so much pictorial ambition into painting Silenus, we might say that the figure of Silenus was for Rubens a bodily and hence picturable instance of *liberté* with abandon clearly entertained.[10]

Let us try to follow the painting's growth. A pen drawing, which characteristically repeats the half-length Silenus twice over, allows us to trace the transformation of a corpulent seated

84 Reconstruction of the three stages in the process of expanding the *Silenus*.

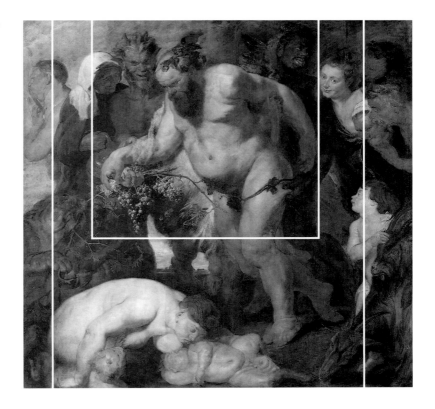

model into a seated Silenus accompanied by a second (satyric?) figure and, diagonally up the sheet (the delineation of the stomach overlapping the shoulder of the first figure), into a standing, forward-leaning, vomiting Silenus, his arm gripped from behind by a third figure (pl. 86). In the first stage of the painting (as recorded in the Kassel work), this standing, forward-leaning Silenus rests his right hand on a grape-vine, an old woman's head is added beside that of the satyr at the left, the gripping figure is black and he now seizes the (hairy?) flesh of the great man's thigh (pl. 84). It remains Silenus's painting, but he is exposed to, dependent on, and used by others. Expanding below as well as a bit to each side in a second painted stage, Rubens made Silenus full length and fully, though idiosyncratically, human. (A horizontal break marking the edge of the original

115

85 (facing page)
Seated Nude Man.
Black and white
chalk, 43.5 × 36.8.
Museum Boymans–
van Beuningen,
Rotterdam.

86 Studies for a
drunken Silenus.
Pen and ink, 29 ×
19.5. Formerly
collection of
Count A. Seilern.

panel is visible just above and to the left of Silenus's forward knee.) His thighs resituated, he now lurches forward on one leg, dragging the second, shadowed one which is doubled by the dark leg of the black man behind, taken up in front by the hoofed leg dangling from a goat-skin cloak, by something that might be the right leg and heel of the black man, and by the leg of the satyr dark against a distant horizon, and, in addition to all these, by the foot of the drinking celebrant. Activity and energy are released through this repetition of limbs with an effect not unlike the optical play in Duchamp's *Nude Descending the Staircase*. (Rubens might have recalled the rhythmic tangle of legs in the Mantegna *Bacchanal with Silenus* that he once copied [pl. 74].) The head of a young woman − companion to the older woman to the left? − is added to the right. In the third and last stage of the painting, narrow panels to each side couple the head of a man with that of the young woman, add heads of an elderly couple above a child and a pair of copulating goats, and a tiger (once again a head) toys with the grapes and a piper leads the expanded procession in front. Silenus's illuminated belly, prominent navel and shadowed genitals are at the center. And fecundity is invoked by, displaced onto, the phenomenal invention of the earth-mother satyress on the ground below, suckling twin panisci, her children, with distended, blue-veined breasts, while fondling (to placate him?) the penis of one. With the nipple of bulging breast gripped by the small mouth, and milk leaking down the drowsy animal/child's cheek, Rubens bares the physical satisfactions of what is usually described, and painted, as maternal nurture (pl. 87). Not a Madonna, she is a match for Silenus. Rubens has need of and feeling with her.[11]

Aside from the satyress, his non-mate, Silenus is effectively rung round by heads. The format is not unlike that used for a Christ mocked carrying the Cross.

It was not unusual for Rubens to start with the central portion of a painting, subsequently adding to it. His bridal picture of Helena Fourment (Munich) began as a half-length depiction, with legs and décor to both sides added later. The impulse to expand, the need to continue working, the reluctance to leave off

87 Detail from *Drunken Silenus* (pl. 63).

118

88 *Bacchanal.* Oil on
canvas transferred from
wood, 91 × 107. Formerly
Hermitage, St. Petersburg,
moved to Pushkin Museum
in 1930.

– three aspects of a single phenomenon – are related to Rubens's
habit of adding bits of paper to extend his drawing surface. (We
might contrast this with Rembrandt, the etcher, cutting down his
plates, or Manet cutting his paintings up into several pieces.) But
in the case of the *Silenus*, the development through expansion has
another and most particular element: it changes the nature of this
mythic figure by socializing him.[12]

Earlier, Rubens had painted Silenus in a sociable setting with

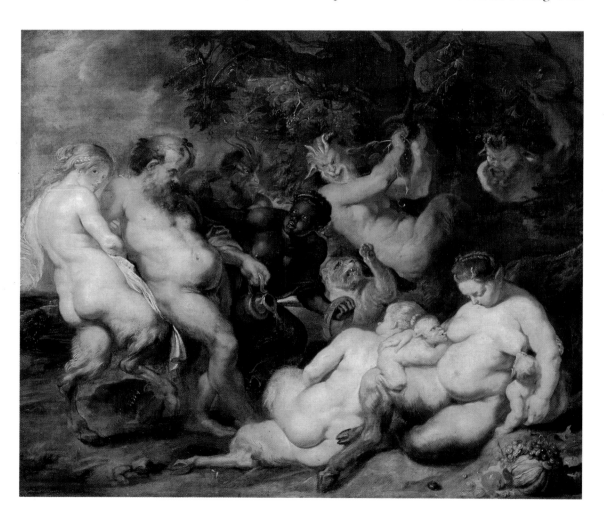

suckling faunesses, satyrs and wild beasts. The world was a bacchic one, the scale small (91 × 107). The painting, now in Russia, is the Munich picture *in nuce* (pl. 88). But he began the Munich painting with an (almost) isolated Silenus and the half-length figure about life-size (the Kassel painting is 139 × 119) (pl. 79). As a creator, Silenus was an isolate. He had no mate, and his songs were his alone. Rubens begins by positing him in this asocial state. And then he eases up on it. When he adds figures, he expands beyond the mythic or bacchic world: nature and culture, black and white, youth and age, peasant and burgher, beasts wild and domesticated, and the satyress and her kids in-between. Silenus has relinquished his bestial hide to become a captive at the center of the world. Perhaps there is reference to his festive capture at the hand of the Phrygian rustics who brought him to King Midas. But this is not "une yvresse gaye." He is a curious figure indeed – infantalized, regressive, in part a huge, blown-up version of the little half-animal satyr child at his feet and recognized as such in the glance of the child looking up from the right.

Roger de Piles's description of Richelieu's *Silenus* as an example of the highest degree to which painting can aspire is not misplaced. In his comments on the painting, de Piles emphasizes the unifying arrangement of light and shadow: Silenus is the principal light surrounded by shadows – the black man behind, the black-robed old lady before – which set off the secondary lights of a kerchief, various heads, a child behind, the pale, drunken satyress/fauness and kids beneath. Following the Pilesian optical logic, these secondary lights also serve as reflectors for Silenus. His luminance depends on the others about him – the couples, the mounting goats and, optically most significant, the pallor of the fauness/satyress and suckling panisci. In praising its "force tout ensemble extraordinaire" ("tout ensemble" being his term for pictorial unity), de Piles is praising the pictorial socialization of Silenus. And it is curious, given that Bacchus and his followers were family deserters, that there is an insistence on couples. Rubens is, after all, the artist who thought to supply a mate for each of the river gods in his *Four Parts of the World* (pl. 104). The Munich painting tends towards a social, bourgeois,

89 Anthony van Dyck, *Drunken Silenus*. Oil on canvas, 212 × 266. (Destroyed, formerly Kaiser-Friedrich Museum, Berlin).

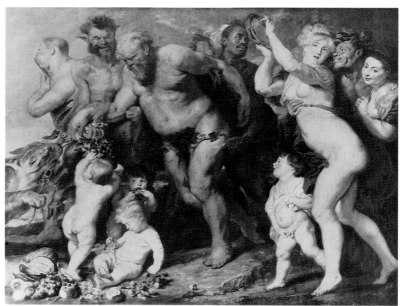

90 Anthony van Dyck, *Drunken Silenus with Faun and Bacchante*. Oil on canvas, 133 × 90. Musées Royaux des Beaux-Arts, Brussels.

91 Anthony van Dyck, *Drunken Silenus*. Oil on canvas, 107 × 91.5. Gemäldegalerie, Dresden.

familial version of a bacchic train, with Silenus, the motive and motor of it all, alone at the center.[13]

Something is lost or hidden in the process as Rubens transforms by expanding his Silenus, alone and exposed, into this procession in the world. It would perhaps be truer to describe the Munich painting as divided within itself: the huge, naked, drunken Silenus inattentive to, oblivious to the world ("son insensibilité au mal qu'on luy fait") of which Rubens makes him – now obviously mocked ("toute occupées à se mocquer de lui") and also penetrated – a problematic part.

When he was still Rubens's leading assistant, Anthony van Dyck, in his version of the Munich painting, attempted to counteract or minimize the ambiguity by replacing the satyress and her suckling kids beneath with two playful putti and adding a maenad – today we would call her Madonna – flaunting her nudity to one side and attracting the black man (pl. 89). He had similarly diminished the ambiguity of the painting's first stage by offering in the background of his versions of it, as balance or

122

corrective to the problematic Silenus, the fixedness of either a clearly all male or a male/female flirtation (pls. 90, 91).

The Munich painting is a departure from, or at best a particular inflection of, contemporary interest in Silenus. Though Silenus occasionally appears in Renaissance paintings as a minor bacchic figure of fun (Bellini, Piero di Cosimo, the Mantegna that Rubens copied), his presence in Rubens's Europe was mostly in texts and in a particular serious vein. In *The Symposium*, Plato, speaking through Alcibiades, had likened Socrates, in his unlikeness to other men, to an ugly Silenus. This passing reference gave impetus to the notion of the wise/fool, or wise/drunken fool, or wise/drunken author as variously invoked by writers such as Erasmus, Montaigne, Rabelais, and Shakespeare among others.[14]

In the pictorial tradition, Socrates and Silenus, in particular the physiognomies of the two heads, coalesce, so that the image of Socrates is identifiable by his Silenus-like appearance. In a singular pictorial example, the neo-platonic emblem-book of A. Bocchi, Socrates/Silenus is combined with Virgil's poet-Silenus to create an image and supporting motto of a distinguished, toga-ed figure, attended to by a pair of (Virgilian?) satyrs and crowned by both Venus and Minerva (pl. 92). In a pithy digest of Silenus traditions, the good life is said to combine pleasure and virtue, or Voluptas and Virtus in the words that Bocchi's motto puts in Silenus's mouth. It is striking that, in the interest of the learned point, the bacchic side of Silenus is nowhere in view. Bocchi, assuming he knew it, might have interested Rubens, because his is a Silenus with a dignity that the images of the drunken one normally lack.[15]

Rubens was not one to deny wisdom to painters. A case could be made that Socratic wisdom and the melancholy attendant on a Renaissance version of it have a part in the invention of the Munich Silenus who, in contrast to the figure as he had been depicted in the earlier *Bacchanal*, or the Genoa or Kassel pictures, has human limbs and a vaguely Socratic physiognomy. Among the antique cameos Rubens owned was one of a vine-wreathed Silenus-appearing Socrates, and he drew a design for a back-to-back head of a Silenus/Satyr herm in which the Silenus profile

92 Giulio Bonasone, *Minerva and Venus Reconciled*. 1573. Woodcut, from Achilles Bocchi, *Symbolicae Questiones*.

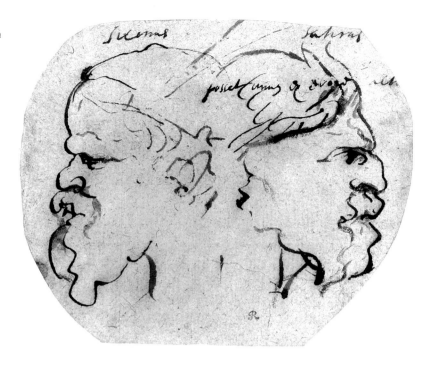

93 *Twin Heads of Silenus and a Satyr.* Pen and brown ink, 11 × 12.7. British Museum, London.

is of the Socratic type (pl. 93). The grafting of aspects of the Socratic type onto the Silenus-type is visible in Rubens's reworking and expanding of his original painting (Kassel) into the painting now in Munich: goat legs become human ones, the hide is replaced by a hide-cloak, and the satyr-type head becomes a more human one.[16]

But Rubens's Silenus is less Erasmus's Silenus-Alcibiades – ugly on the outside, hiding wisdom within – than he is the Silenus of Rabelais in the prologue to the *Gargantua*, offering a rhetorical boost through the association of drinking with the creative state of the artist-poet. Rubens is more concerned to emphasize the impressive bearing of a drunkard than the drunken stance of a wise man.

One can differentiate a jovial, backward-leaning Silenus from a more somber and serious forward-falling one. It is in the latter format, the one that Rubens took up for what he gradually

94 Detail from *Drunken Silenus* (pl. 79).

124

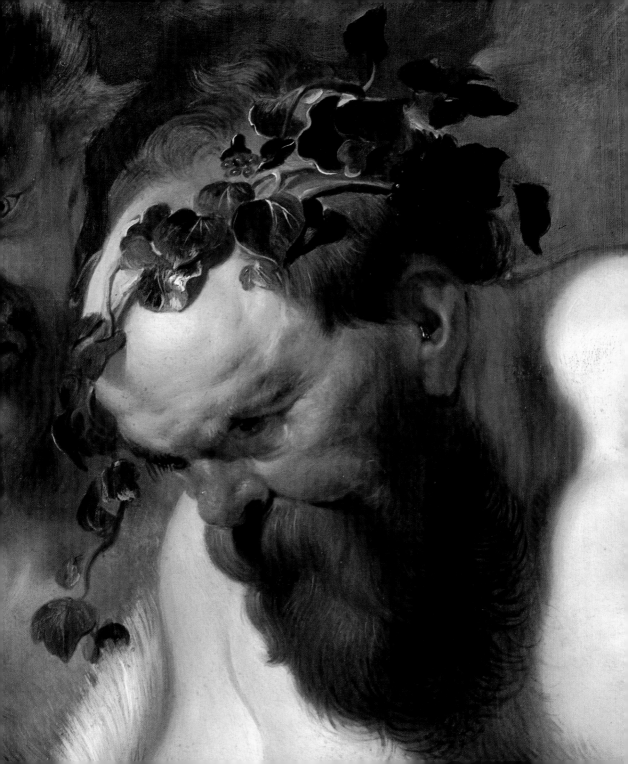

worked into the Munich painting, that intelligence and melancholy become attributes. In the small *Bacchanal* of the serious type (though here backward leaning) in Russia, Rubens first assembled the figures and displayed the interest in flesh that was expanded in scale, articulation and ambition in the Munich picture (pl. 88). But the two Silenus types have in common an interest in flesh. A certain kind of bodily presence is at issue. It is necessary to accept, as Rubens did, the condition of the flesh and not seek to mollify or escape it through a (scholarly) appeal to the intellect. It is the absurdity of making such a grand presence out of this flabby, drunken, marginalized and mocked body that one must acknowledge and somehow come to terms with.

Rubens's attraction to Silenus's opulent flesh, the result of age and a dissolute life, is all the more powerful because it overrides his stated distaste for bodies badly maintained. In the Latin treatise he wrote on the imitation of ancient statues, which was eventually published (with a French translation) by de Piles in his *Cours* of 1708, Rubens lamented the flabby, shapeless bodies of the modern age compared to the beauty of the healthy bodies available to sculptors in antiquity. Despite this attitude, Rubens, perhaps while still a young man in Antwerp, studied Silenus's flesh in his pen drawing after the engraved *Bacchanal* by Mantegna and collaborated on the painting after the same work, in Rome he made the drawings after the Roman statue now in Dresden and of the Borghese vase relief.[17]

Back in Antwerp, he turned to the live model and made a remarkable, large − almost a half meter high − chalk drawing of a fat man (pl. 85). Rubens commonly found the human bodies for his art in art: they were part of what he took to be his pictorial inheritance. For a painter whose work is grounded in the human body, it is notable how few and far between are his drawings after the naked model. (Rembrandt did many more of men and women alike. Given the subjects of their paintings − Rembrandt an infrequent painter of the nude and Rubens a continual one − the contrast between the two artists in drawing after the model is surprising.) With few exceptions, Rubens drew his models in a pose devised for a particular pictorial purpose then to be filed away for use as a studio resource. Its departure from his normal

95 Detail from *Drunken Silenus* (pl. 63).

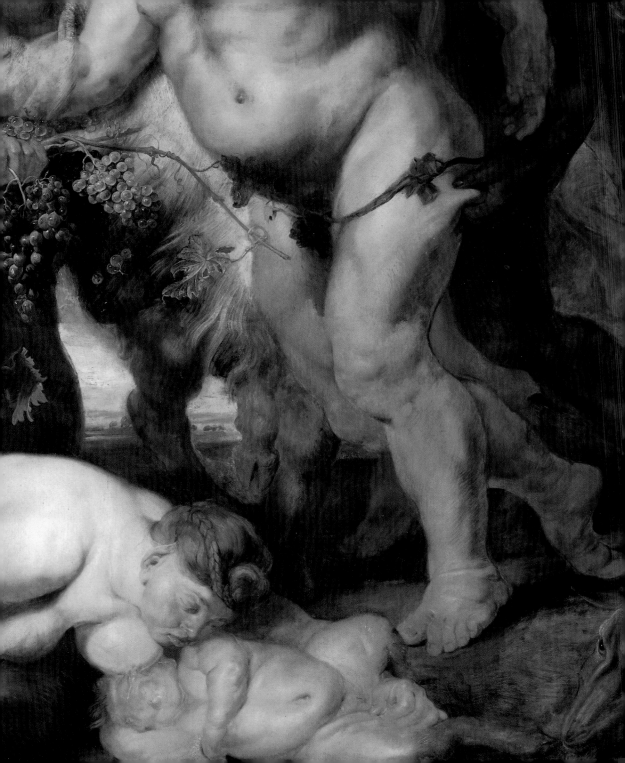

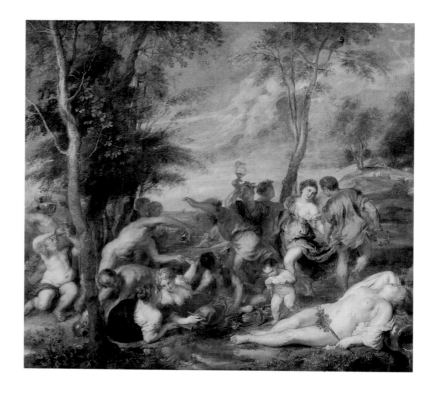

96 *Bacchanal of the Andrians*, after Titian. Oil on canvas, 200 × 215. Nationalmuseum, Stockholm.

practice makes the loving drawing of a corpulent, seated man all the more exceptional.[18]

Rubens was comfortable working in a pictorial tradition in which, since the sixteenth century, the painting of the nude had largely been gendered female and the women mature – though the maturity was emphasized more by the heirs to Titian than by the master himself. (Rubens had, one realizes, little taste or feel for that other tradition, renewed again in post-revolutionary France, featuring a nubile male, who is either suffering – often as St. Sebastian or Christ – or the potential cause of "suffering" from love as Amor/Cupid [pl. 44].) The representation of female flesh was bound up with the medium of oil paint from its early use in Italy. The representation of the female nude was implicated in the Venetian invention of using the medium of oil paint to fabricate the sensual surface specific to female flesh. The

128

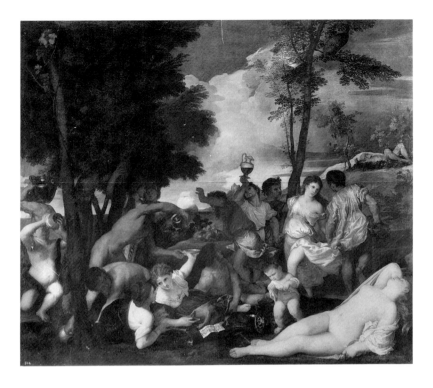

97 Titian, *Bacchanal of the Andrians*. Oil on canvas, 175 × 193. Prado, Madrid.

originating figure was the *Venus* of Giorgione. The interest in the oil/female flesh relationship continues in painting into the nineteenth century with Ingres and Manet.

Rubens is rightly seen as part of this tradition. He is notable as a painter of flesh. But modern viewers have tended to remember him, even dislike him, as a painter of female flesh. Though it is memorable, flesh in Rubens's paintings is hardly beautiful surface. It is, instead, the all too solid human stuff. One can take the measure of his difference by considering the female bodies in his *Bacchanal* in Stockholm alongside those in Titian that he took as his model in mind (pls. 96, 97). Rubens gives up skin surface differentiated by the play of light in the interest of solid flesh. One can say that flesh on Rubens's account is not surface, but rather the matter or material out of which all human bodies – men's and women's alike – are formed. He is also a painter of

98 (above left) *St. Sebastian*. Oil on canvas, 200 × 128. Gemäldegalerie, Berlin.

99 (above right) *Andromeda*. Oil on panel, 189 × 94. Gemäldegalerie, Berlin.

male flesh: flesh as he depicts it is something in common between men and women. How similar, in this rendering of flesh, are his *St. Sebastian* and his *Andromeda* which hang near each other in Berlin (pls. 98, 99). Compare the buttocks of a river god and those of Venus herself (pls. 103, 104).[19]

If we look at Rubens's *Bacchus* now in St. Petersburg, another of the paintings once owned by Richelieu and praised by de Piles, we see that men can be depicted, in respect to flesh, even

101 Detail from the *Fall of the Damned*. Oil on panel, 288 × 225. Alte Pinakothek, Munich.

100 (previous page) *Bacchus*. Oil on canvas, transferred from wood, 191 × 161.3. Hermitage, St. Petersburg.

as women are (pl. 100). In Rubens's representation of them, men can take on a fleshly nature which, given the pictorial tradition in which he is working, can be described as female or androgynous. One could say that, on Rubens's account, men can aspire to, but also acknowledge themselves to be in the condition of a woman. Of this human fleshly root, this fleshly communality, this conundrum (for on Rubens's account human flesh is not only a condition for celebration it is also the condition of damnation, for which see the bodies in his Munich *Fall of the Damned* [pl. 101]), his Silenus is a commanding example. It is this that the great rounded belly with its prominent navel, the pinched thigh, the penetration from behind are intended to display. (In the knee-

132

length workshop version described by de Piles and now in London, the hand of the black celebrant is corrected so as to rest instead on a flank [pl. 102].)

What is curious, and to us visually disturbing about Rubens's Silenus or his Bacchus, is that it is the mature female flesh of the painting tradition of the nude that is attributed to, accommodated to, men. It is this, perhaps, that the nineteenth-century moralists who take against Rubens for his vulgarity are reacting to in his painting. Thomas Eakins, for example, was outraged. He wrote his father from Madrid that "Rubens is the nastiest most vulgar noisy painter that ever lived. His men are twisted to pieces. His modelling is always crooked and dropsical and no marking is ever in its right place or anything like what one sees

102 Workshop of Rubens, *Drunken Silenus*. Oil on canvas, 133.5 × 197. National Gallery, London.

103 *Venus at the Mirror.*
Oil on panel, 124 × 98.
Gemäldegalerie,
Lichtenstein.

104 (below) *Four Parts
of the World.* Oil on canvas,
209 × 284 (cut down on
all sides). Kunsthistorisches
Museum, Vienna.

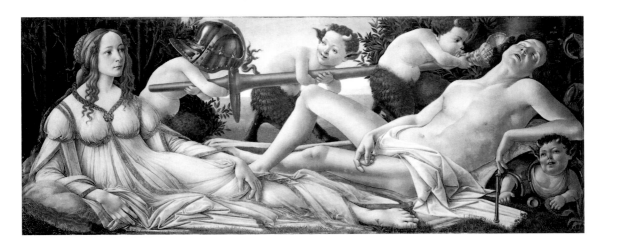

105 Sandro Botticelli,
Venus and Mars. Panel,
69.2 × 1.73. National
Gallery, London.

in nature . . . His pictures always put me in mind of chamber
pots." But it was through his identification with Silenus that
Rubens could, to recall Ruskin's words on the Louvre *Kermis*,
endure the sight of his imaginations (*sic*) in painting images such
as these.[20]

In our day, when it is often insisted that paintings register or
construct gender *difference*, it is salutary to remind ourselves that,
in their commitment to the representation of the human body,
European artists have often called attention to it as something in
common between man- and womankind. Quattrocento painters
it could be argued – for example, Botticelli in his *Venus and Mars*
in London (pl. 105) – accommodated men and women alike to
a single pre-pubescent type which was then taken up by the Pre-
Raphaelites with a more decidedly female tilt. Photography has
been a site of this sense in our time, and the accommodation can
move in the other direction: instead of men taking on the flesh
of women, women are represented taking on male muscle, as in
Robert Mapplethorpe's photographs of the body-builder Lisa
Lyon. A Rubensian effect in the Silenus mode is realized by
Lucian Freud in paintings using the huge and lushly fleshed,
transvestite performance artist Leigh Bowery as model (pl. 106).
The breasted, shaved, mountainous figure, pink flesh bulging to
fill large canvas, is Silenus come to life. (Bowery's description of

106 Lucian Freud, *Naked Man, Back View*. Oil on canvas, 183 × 137.25, Metropolitan Museum of Art, New York.

himself as "an unusually big heifer" suggests what the pictures confirm: a model to Freud assumes something akin to the sacrificial role of the ancient drunkard.) But a real Bowery was necessary to enable Freud, though long a painter of naked bodies, to discover that fecundity of flesh native to Rubens's figural imagination.[21]

Rubens's sense of flesh, in particular Silenus's flesh, was noted by his eighteenth-century French devotees. In Watteau's *Gersaint's Shopsign*, which depicts connoisseurs attentive to painted flesh, Rubens is represented not by a picture of a woman, but by a Rubensian Silenus – the format is that of the Genoese Silenus (pl. 68) – endowed with breasts (pl. 107). Watteau confirmed his understanding of Rubens's gender blurring in a chalk drawing he made after Rubens's studio *Procession of Silenus* (pl. 108). He adjusts the hand of the figure following behind Silenus so that it rests not on his flank, a displacement from the pinched thigh, but on *his* breast.

107 Detail from Watteau, *Gersaint's Shopsign* (pl. 50)

108 (below) Jean-Antoine Watteau, *A Procession of Silenus*. Red, black and white chalk, 15.4 × 21. National Gallery of Art, Washington, D.C., Gift of Mr. and Mrs. Paul Shephard Morgan to honor Margaret Morgan Grasselli, Curator of Old Master Drawings, and in Honor of the Fiftieth Anniversary of the National Gallery of Art.

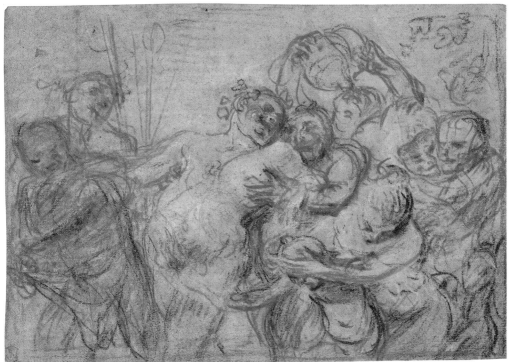

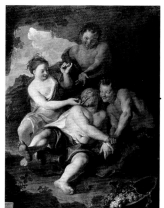

109 Antoine Coypel,
*Silenus Smeared with
Mulberries by Aegle*, 1700.
Oil on canvas. Musée des
Beaux-Arts, Reims.

110 *Bacchanal (Silenus and
Aegle)*. Pen and ink, with
wash, heightened with
white, 14 × 12.5. Stedelijk
Prentenkabinett, Antwerp.

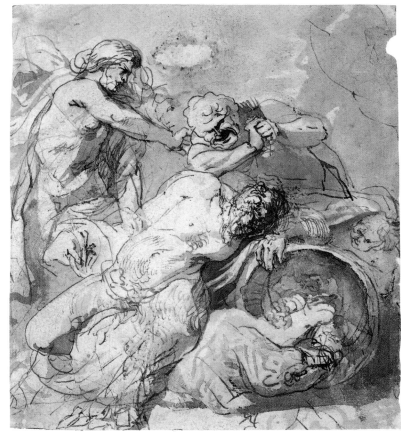

But in the French painters who came after, Rubensian flesh
reverted to its gendered association with women. Part of their
lack of Rubens/Poussin discrimination, as we have noted, was
their tendency to revert flesh to being a female attribute.
Through a kind of willful misunderstanding, the material nature
of Rubens's depicted flesh becomes narrowly eroticized. The
feminization of Rubens in the French eighteenth century has to
do with taking up his representation of flesh, but it is also a
misunderstanding of the androgynous possibilities it offers. An
example is the *Silenus Smeared with Mulberries by Aegle* of 1700 by

Antoine Coypel (pl. 109), which is based on Rubens's Antwerp drawing then in the collection of the comte de Caylus (pl. 110). The prize-winning *The Drunkenness of Silenus* of 1747 by Charles-André Van Loo (pl. 111) disarms the disturbing potency of Rubens's Silenus. Although it is the overpowered Silenus of the drawing (legs spread apart, one knee thrust up and out) that Van Loo puts into the processional format, the result is a jovial, flabby, unthreatened and unthreatening fat man.[22]

What is disturbing about Rubens's Munich *Silenus* is that in it gender difference is unclear. Difference is denied, or at least not marked: the body is not clearly male, nor is it female. In appearance and in behavior he exists, on Rubens's pictorial account, in a curious no man's and no woman's land, between or eliding genders.

Chère maître, was how Flaubert addressed George Sand. And after her death, he remarked on how much femininity there was in that great man.[23]

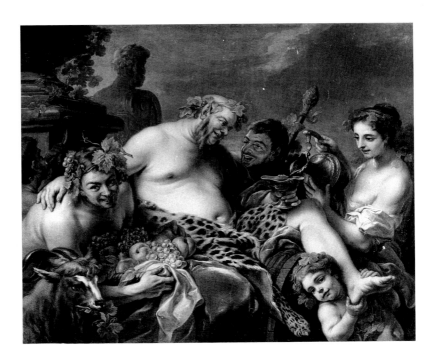

111 Charles-André Van Loo, *The Drunken Silenus*. 1747. Oil on canvas, 164 × 195. Musée de Beaux-Arts, Nancy.

Perhaps, this is us all.

Why would a male painter in our tradition represent flesh in this manner? I think it has something to do with the problem of male generativity. How are men to be creative, to make pictures, for example, when giving birth is the prerogative of women? For all the talk about the gaze (which, in a curious construal of the Lacanian notion of finding oneself through being looked at, has been attributed to the figure of the authoritative male painter), the pictorial record reveals the problems men have felt about creating as painters in our tradition. Not only do they summon up female muses in various forms, but it is notable the number of painters of achievement in the western tradition – Donatello, Leonardo, Michelangelo, Degas – whose own sense of gender was complex, under pressure and, further, was manifest as such in their figural modes. And we might think of their identifications – Donatello with Mary Magdalene, Michelangelo with Bacchus, Manet with Victorine Meurend, Degas with women bathing or preparing to dance. Silenus served Rubens in this way.[24]

The frequent image, self-image or portrait, of the artist is of a man standing before and back from his canvas, looking at it, often a man with a woman in view. The problematic of the artist so conceived has received intense consideration. Instead, like a painter embodied in his paintings as a given, from the start as it were, Silenus is part of the songs that he is making. This is to picture an artist fused with his work, not standing back but in the process of making. This is not performing as for an audience, but performing in the sense in which a dancer performs in the midst of "making" his/her dance. It is an ecstatic or, to invoke Nietzsche's distinction which does not seem inappropriate here, a Dionysian rather than an Apollonian notion of art. In *The Birth of Tragedy*, Nietzsche argues the originating role of the satyric chorus, and, as folk wisdom anterior to this, he retells the tale of the capture of the prophetic Silenus by King Midas. These ancient subjects, and the sense that identification with them was at the root of (dramatic) art, are relevant here: reading *The Birth of Tragedy*, a later work in the same tradition, can stimulate and sharpen our view of the bacchanalian Rubens.[25]

Nietzsche's only pictorial reference takes the form of a canny

distinction between the Apollonian upper, and Dionysian lower half of the *Transfiguration* of Raphael, himself an Apollonian. The plastic artist, Nietzsche says more than once, images things as outside himself: no dionysiac he (or she). This is again the artist imagined/imaged as standing back from the canvas and from the world. But I think, *pace* Nietszche, that the Dionysian model is more appropriate to a painter than to a writer whose physical act of writing is necessarily separate from his text. Silenus was an oral poet, and Virgil finds a voice in him. For Virgil a text is necessary to render in words what Silenus sings. But voice as such is not the issue for a painter. Perhaps role takes its place. Rubens, on this account, identifies with the bound singer Silenus rather than with the poet writing about him. Silenus, for Rubens, is not the conscious creating of an outlet or voice as he was for the poet, but the embracing and figuring forth of a particular situation or creative state. This is the imagined site (the metaphor is that of the studio) of Rubens's creating: drunken, tied down by a pair of shepherd/satyrs and, as his brow is stained by a nymph, waking and beginning his extended song. Silenus embodies an ecstatic notion of creating art.[26]

The kinship Rubens/Silenus takes us a bit further into Rubens's workings as an artist than he might consciously have been willing or even able to acknowledge. Reading the poetry of Virgil's Silenus provides us with the terms to describe certain basic idiosyncracies of his performance as a painter. We might speak of this as Rubens's Silenus mode. A major consequence, then, of considering his kinship to Silenus is that it focuses our attention on certain of Rubens's thematic interests as well as on certain patterns in his practice as a painter.

Commentators since Servius have puzzled over the sixth Eclogue, second only to the Messianic fourth in the interpretive and poetic problems it presents. Why Silenus? And what kind of a poetic performance is he part of?

First, lest there be any doubt, let us briefly review the evidence of Rubens's interest in and knowledge of Virgil. We know from his early biographers that he was a Virgil-reader. He collected the Roman poet's expressive descriptions in a notebook that has, famously, been lost. And in one of the several accounts we have

of Rubens at work, he is described quoting in Latin and from memory extensive passages from the *Aeneid* even as he was working at his paintings after it. One imagines that a similar immersion in the text produced the two drawings of the Silenus of the sixth Eclogue, which are generally thought to have been made in the years following his return from Italy (though this could mean anywhere between 1608 and 1620) (pls. 110, 112). The first, as we have seen, registers his capturing and binding down. The second is more peaceful. The recumbent Silenus, now overpowered, lets himself be administered to by Aegle. Viewed from behind, her body lodged (as a man might press himself on a woman) between his thighs, she stretches across him to stain his brow. Something of the pouring out of the bound drunkard's song is suggested by the incantatory repetition of figures across and up the broad sheet. But the actual activity is on the part of Rubens's liberated pen.[27]

An inscription in his hand at the top of the second drawing reveals Rubens to have been puzzling over Virgil's text as he was working. Elizabeth McGrath, with her keenly sympathetic sense of Rubens's scholarly and artistic ways, has discovered that the Latin words, long a puzzle to the experts, are related to a particular Virgil commentary. Read as "vitula – gaud[ium]" (or "vitula means joy"), the note appears to register Rubens's curiosity about the word "vitula". This interest of Rubens was apparently taken up in the course of tracing the word "Pierides" (a reference to the muses which occurs in Eclogue VI, 13, just before the appearance of Silenus), through the commentary of Pontanus, whose edition of Virgil he evidently had to hand while he was drawing.[28]

But the drawing also confirms his taking up of the text he read in a *pictorial* sense. Rubens transforms and internalizes the serial verbal invention into drawing. His pen repeats the gesture of Aegle the nymph, twisting and tending to the fallen Silenus, three times over (her third head almost lost beneath other figures at top right), and the pen's movement generates further curiously related mythic figures. Aegle's pose is akin to Rubens's Jupiter/ Diana twisting over in seducing Callisto and to the figure of Victory twisting over in crowning the Hero. There are in ad-

dition, it has been suggested, as the ink gives out and the hand slows, a hint of the river gods from the Vienna *Four Parts of the World* and of Meleager's struggle with the uncles.

The two Silenus drawings are not isolated instances. The condition of Virgil's Silenus – in a textual but also in a bodily sense – can be said to resonate throughout Rubens's works.

Reading Virgil's sixth Eclogue with Rubens's production in view there seem, in sum, three relevant, and inter-related, points.

Firstly, the Silenus mode of inventing is serial – a pouring out which is a compendium of poetic precedents. Virgil's Silenus, not unlike Rubens himself, was an actively nostalgic ancient.

Secondly, Silenus not only makes things happen but, like Proteus (another figure to whom he is related in myth), he transforms himself into the experience of those, including women, of whom he sings – identifying, for example, with the desperation of Pasiphae in her love for a bull.

Finally, and related to this, as textual commentaries from Servius on have noted, passages are written so as to make Silenus not just the singer of, but the creator of the events of which he sings. Silenus not only tells about, he also brings about the pain, death, metamorphoses that come to those captured by love – *captus amore*. It is he who makes Pasiphae love a bull and surrounds with moss and bitter bark the sisters of Phaeton so metamorphosing women into trees. A modern commentator on Silenus's Orphic mode locates the phenomenon in Virgil's use of language itself, fixing on the construction "tristia condere bella" (l.7) which is, on his account, the first occasion in Latin poetry when an accusative placed after the verb "condere" (to conduct) refers to an object being composed or made (here wars) that is something other than a poem.[29]

It is worthwhile to stop for a moment to imagine Rubens imagining the first state of the Munich *Silenus*. It goes against his whole career as a public man. But I would argue that it is a wellspring of his art. The painting in Munich is but one instance of his dealing with something with which he must have continually dealt.

With the nature of Silenus and of his performance in mind – drunken, bound, taken over, seized, *transformed* into a mouth-

112 (following pages) *Silenus, Aegle and Other Figures*. Pen and ink, with washes, 28 × 50.7. Royal Collection, © 1994 Her Majesty Queen Elizabeth II.

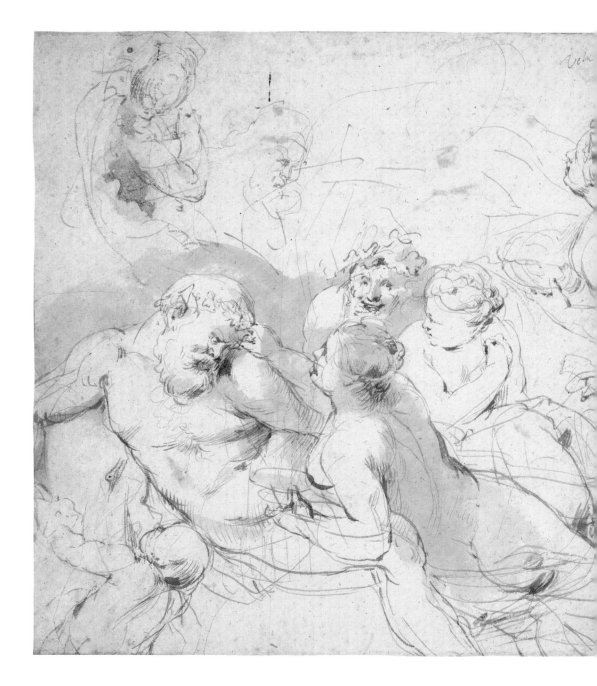

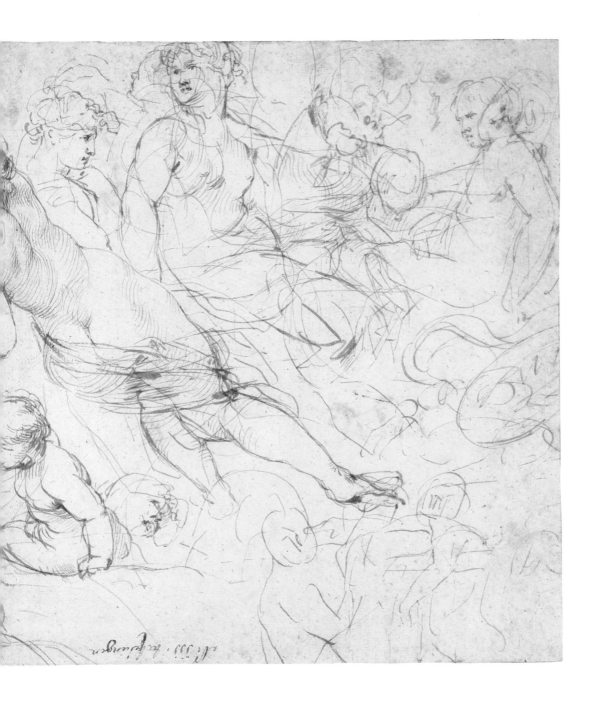

piece, as it were, for songs – let us consider some aspects of Rubens's artistic practice by way of locating the practical aspects of his identification with Silenus. Some old things can be seen in a new light. For example, the copies after other painters which were Rubens's extension of a learning habit into a lifetime project reaching its peak in copying, on a contemporary's account, all the many Titians in the Royal Collection in Madrid. Protean could well describe Rubens's relationship to tradition in his astonishing copies of Raphael's *Castiglione* or Titian's *Andrians* (pl. 96) or *Europa* – transforming himself into and thus in a sense serving as the medium of other artists, as did Virgil's Silenus according to the account of the sixth Eclogue as a "catalogue" of poetic predecessors.

Abandon is hardly a state we associate with Rubens, the master of a hugely successful Renaissance studio. He organized and ran a painting factory. It was characterized by a division of labor: by separating his inventions from their execution by the studio at large, he was able to oversee the production of over three thousand paintings, engravings and woodcuts. But there is another aspect to Rubens inventing – less calculating, less obviously under control. We have looked at a couple at their dance, spinning off from the peasants assembled at the *kermis*, twisting and twirling, and weaving back and forth, across and up a large sheet in a perpetual kiss (pl. 29). And now we have before us Aegle staining the forehead of Silenus, also repeating and unfolding across and up a sheet. Rubens matches the singer's outpouring with a host of mythological figures starting with Silenus and Aegle at the left, repeating Aegle twice again across the sheet, Aegle repeated but also Meleager, a bit of Callisto and so on. Such invention, serial invention, is inseparable from execution: such a continuous drawing performance, hardly contained by the page, is like Silenus abandoning himself to his singing.

And the point can be extended. Even if the hands of other painters are deployed in the final paintings – in the series of myths he designed for Philip IV which take up some of myths sung by Virgil's Silenus, or in the scenes from the life of Marie de' Medici – Rubens's serial spinning out of a series of images may be defined as in a Silenus mode. As an eyewitness to Rubens at work

146

wrote, "In an instant in the liveliness of the spirit, with a nimble hand he would force out his overcharged brain into descriptions, as not to be contained in the compass of ordinary practice, but by a violent driving on of the passion." But what is at issue is perhaps not *how* Rubens did it, but the *look* of what he did: "la gran prontezza e la furia del pennello," noted Bellori, the Italian writer on art. "Abandon and audacity alone can produce such impressions," concluded Delacroix, one of Rubens's greatest admirers.[30]

But there are also other things to consider about the Silenus mode, and they bring us back to the question raised at the beginning of this chapter. For like Silenus, Rubens was also Protean in a gender sense. He entertains an interest in cross-dressing: Achilles among the women, Jupiter disguising himself as Diana to woo/seduce Callisto (pls. 113, 114). Then Rubens goes

113　*Achilles among the Daughters of Lycomedes*. Oil on canvas, 246 × 267. Prado, Madrid.

114 *Jupiter and Callisto.*
1613. Oil on panel,
126 × 184. Gemäldegalerie
Alte Meister, Schloss
Wilhelmshöhe, Kassel.

115 *Samson and Delilah.*
Oil on panel, 185 × 205,
National Gallery, London.

116 *Samson Taken by the Philistines*. Oil sketch on panel, 37 × 58. Copyright © Fundación Coleccion Thyssen–Bornemisza, Madrid.

on to transform the latter pair into a quite different erotic tale – out of the Jupiter/Diana figure comes Samson, and out of Callisto comes Delilah in the painting now in London (pl. 115). Here the roles are reversed: the wooer – Jupiter become Samson – is overcome by the one wooed. His dropped arm comes from Jupiter in the print by the Italian artist Perino del Vaga where Rubens found his Jupiter and Callisto. The hanging arm of Silenus is also related to this. Like Silenus, for that matter, Samson was a man overcome by drink, as Rubens indicates by the wine vessels displayed on a background wall shelf.

The chain of transformations does not end here: in a complex, ultimately unusable study for an overcoming or arrest of Samson (pl. 116), Samson's position and his situation are similar to that of the bound Silenus in the Antwerp drawing; Delilah assumes the pose of Jupiter-seducing-Callisto-become-Samson-undone-by-Delilah, which pose Rubens also deployed in drawing Aegle attending to Silenus who here, bringing us full circle, is in the position of the London Delilah and the Callisto seduced. It is not only matters of flesh that men and women have in common – they share also, and hence can exchange, figural stance and role.[31]

One is reminded of the facility with which Rubens exchanges

117 (above left) *Hercules and Omphale*. Oil on panel. 278 × 215. Louvre, Paris.

118 (above right) *Venus Lamenting Adonis*. Oil on panel, 273 × 183 (cut at left). Private collection, Paris.

the poses and roles of men and women in the dual roles he implies for himself when he writes about his feelings on the death of his first wife Isabella – combining Aeneas's stated desire for a journey with the voice and words of Virgil's Dido mourning alone in the empty house after Aeneas's departure:

> Io crederei un viaggio esser proprio per levarmi dinansi molti oggietti, che necessariamente mi raffrescono il dolore, *ut illa sola domo moeret vacua stratisque relictis incubat.* (*Aeneid*, 4.82).

> (I should think a journey would be advisable to take me away from the many things which necessarily renew my sorrow, just as she mourns alone in the empty house, and broods over the abandoned couch.)[32]

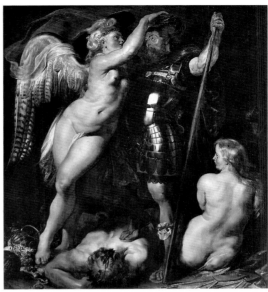

119 (above left) *Drunken Hercules*. Oil on panel, 220 × 200. Gemäldegalerie Alte Meister, Dresden.

120 (above right) *The Hero Crowned by Victory*. Oil on panel, 221.5 × 200.5. Alte Pinakothek, Munich.

Men not only exchange roles with women, they also welcome being subjected to women, court it even. Men undone by women and/or by drink, and the attendant cross-dressing, is an obsessive theme for Rubens. Women *are* fearful – as in his pendants of *Hercules and Omphale* and *Venus Lamenting Adonis* (pls. 117, 118). Rubens's interest in the situation of Silenus – "captus" in Virgil's words, though not, like those of whom he sings, by "amore" – alerts us to this. The Laocoön pose so often used to characterize put-upon men – Hercules at his spinning, as well as the dead Adonis and the Silenus overpowered by Aegle in his Virgil drawing – is welcomed. Rubens imagines it less as a sign of a violent struggle against death, than as a willingness or openness to being taken. As such, it is a pose also assumed by women, being close to the *Europa* of Titian which Rubens copied when in Spain. And in this pictorially related series of couplings, it matters not if men aggress, are aggressed against, are attended to, or are suppliants. Whatever their posture, they are by women overwhelmed.[33]

It is clear that pendants like the *Drunken Hercules* and *Hero*

Crowned (pls. 119, 120) might well be designed as a lesson: how not to behave, Hercules; and how to behave, Victor. However, Rubens's painting complicates this sense: though the Victor clearly rejects, by standing upon, the flesh of bacchic Drunkenness and Lust, he is crowned and all but smothered by the embrace of a fleshy woman. Overcoming and being overcome are combined. In a different sense, this is Samson or Silenus. Rubens often works things out pictorially in the interplay of figural pairs. In effect, what iconographical studies have often attended to in these instances – the meaning(s) of a single figure such as Samson, or Hercules, or Silenus – is secondary to, replaced by, the picturing of figural interplay. Again and again, being subdued by, taken by, or giving over to a female body is pleasurable and in a significant sense necessary to male achievement on Rubens's account. As his interest in Silenus makes clear, it is not the power of women – another iconographical preoccupation – but the pleasure and productivity of male submission that engages him. But to put it that way is to limit the more expansive, less sharply differentiated notion of gender that masochism, such as that of Silenus and of Rubens, as I see him, entertains.[34]

There is, it must be admitted, something counter-intuitive about considering Rubens in this way. He is often seen as a, even *the*, crude painter of men on top. The canonical example of this is his *Rape of the Daughters of Leukippus* (Munich), which represents two armed horsemen who are lifting and carrying off two apparently struggling women. It has been argued, by way of explanation, that Rubens subscribes to and celebrates the notion of a ruler's prerogative over his citizenry, or the notion, established in antique texts, of passion overcoming chastity. Male abduction of women, on this historically sanctified account, is the appropriate path to seduction and marriage. But it looks as if Rubens had problems when he tried to bring this notion up to date. His unresolved and, to my eyes at least, awkward painting of the *Rape of the Sabine Women* (London), results from trying to present what was believed to have been Roman male virtue in contemporary dress, as current behavior. (De Piles, describing this painting in the collection of Richelieu, identifies the central

man with the patron of the painting and the Sabine he is after as his desired wife!)

Rubens, it seems, could paint contemporary and consensual scenes of seduction, as in the *Garden of Love* (pl. 40) (sometimes said to depict Rubens ushering in his young wife, Helena), or scenes that are not contemporary and not consensual, as when satyrs are chasing nymphs, but he had difficulty in a work that was contemporary and not consensual: he had difficulty with depicting contemporary mass abduction. The exceptional *Worship of Venus* (pl. 30) works by a combinatory tactic: present (women worshipping Venus in contemporary dress) is mixed with mythic past (frenzied dancing satyrs with nymphs) without raising the question of consent. Indeed, the painting could be described as a fantasy of female ecstacy. The satyrs are not there on the make, but to lend the women helping bodies. Women also take pleasure in submission.[35]

To come to a conclusion, and to connect this chapter to the previous one: my sense is that in his identification with the disempowered, fleshy, drunken singer Silenus, Rubens evokes a desire for access to a potent, ecstatic mode of creating. The eighteenth century's feminized view of Rubens was not, it turns out, so wrong.

In 1977, on the occasion of the four hundredth anniversary of his birth, a small chalk drawing made by Rubens of himself, a rare, private self-portrayal from his last years, was removed from its mount (pl. 123). On the back, another drawing was found. It depicts a nude woman pressed against, almost obliterating a man (pl. 124). (Evidently the sheet began larger: the self-portrait, as is evident from the back of a truncated naked woman executed with pen at lower-right, was cut out of a larger sheet; the couple with multiple-positioned arms, though trimmed at the top, was perhaps made to fit the reduced sheet.)

Lest one has doubts about the relationship between recto and verso, there is a curiously related case, also newly discovered and also involving self-portraiture. Rubens turned over a two-colour chalk drawing of the face of his first wife, Isabella, and on the other side he drew a family group of himself, his second wife, Helena, and their young son, Peter Paul, (pls. 121, 122). The

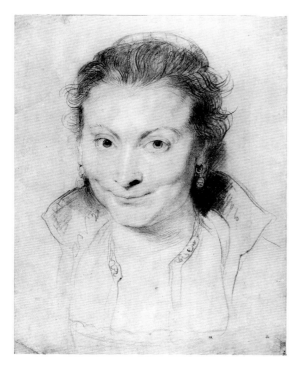 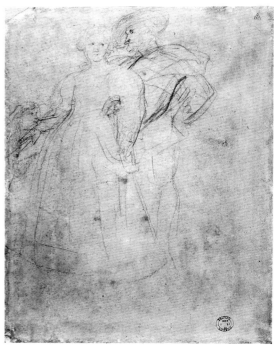

121 (above left) *Isabella Brant*. Black, red and white chalk, pen and wash, 38.1 × 29.5. British Museum, London.

122 (above right) *Self-Portrait with Helena Fourment*. Black chalk (verso of pl. 121).

123 *Self-Portrait*. Black chalk, heightened with white, 20 × 16. The Royal Collection, © 1994 Her Majesty Queen Elizabeth II.

assumption is that Rubens began by drawing Isabella from life in the 1620s and then turned it over to draw his second family in the 1630s. But couldn't it be that Isabella came second, a memory called up in the '30s, when he was amidst his new family? Whatever its history, this sheet is clearly a kind of double cherishing, through the juxtaposition on either side of the two women he married.

But the sheet that concerns us is not elegiac: on one side, the artist's aging face, flesh loose about the eyes, a certain infirmity even in the handling; and on the other, a man's bodily encounter with a woman. One might say that the man's situation – embracing the woman – testifies to the desire for possession which has been not wrongly associated with Rubens. But he is simultaneously possessed by the nude woman who is a sister to Victory crowning the Hero or to Aegle staining Silenus to make him

sing. I find this drawing a final testimony to Rubens's desire – a male desire perhaps – for the merging with a woman that was essential to him in the making of art. The desire manifest is not for power over, but for access to, another mode of experience. Desire may take the form of possession, but when it involves an identification with the object of desire it can be at the same time a desire to *be* possessed. It is an erotics, then, not of possession, but of identification – man with woman. Such male femininity, if that is what it is, offers a more complex sense of masculinity as well as a more complex sense of the relationship between men and women.

When there is a rush, as there is today, to recognize and name the subversive, transgressive and the marginal, it is useful to be reminded that complex notions of identity and of identification are not new. It might be that what is now being construed as exceptional is instead fundamental to human nature and to the ways in which it has been understood. Rubens's Silenus gives evidence of this as he confronts the condition of human generation and creativity. But the Silenus of antiquity, I remind myself, was a marginal figure.

124 *A Man and Woman Embracing.* Black chalk (verso of pl. 123).

Notes

ABBREVIATIONS

CDR *Codex Diplomaticus Rubenianus*, ed. Charles Ruelens and
 Max Rooses, 6 vols., Antwerp, 1887–1909.
Evers I Hans Gerhard Evers, *Peter Paul Rubens*, Munich, 1942.
Evers II Hans Gerhard Evers, *Rubens und sein Werk: Neue
 Forschungen*, Brussels, 1943.
Held 1986 J.S. Held, *Rubens: Selected Drawings*, 2nd ed., New
 York, 1986.
KdK R. Oldenbourg, *P.P. Rubens: Das Meisters Gemälde in
 538 Abbildungen*, Stuttgart and Berlin, 1921 (Klassiker
 der Kunst, 2nd ed.).
Magurn *The Letters of Peter Paul Rubens*, ed. R.S. Magurn,
 Cambridge, Mass., 1955.
Muller Jeffrey Muller, *Rubens: The Artist as Collector*, Princeton,
 N.J., 1989.
Rooses Max Rooses, *L'Oeuvre de P.P. Rubens*, 5 vols., Antwerp,
 1886–92.
Rubens-Bulletijn *Annales de la Commission Officielle instituée par le Conseil
 Communal de la Ville d'Anvers pour la publication des docu-
 ments relatifs a la vie et des oeuvres de Rubens*, Antwerp and
 Brussels, 1882–1910.
Stephan-Maaser Reinhild Stephan-Maaser, *Mythos und Lebenswelt:
 Studien zum "Trunkenen Silen" von Peter Paul Rubens*,
 Münster and Hamburg, 1992.

NOTES TO CHAPTER 1

1. Svetlana Alpers, "Rubens's *Kermis*: A View of the State of Flanders and
 the State of Man. A Summary," *Gentse Bijdragen tot de Kunstgeschiedenis*,
 XXIV, 1976–8, 5–6.
2. It was Rubens's usual practice to touch up the painting done by his studio

assistants. He wrote about the Medici series: "Car aussy bien falloit y retoucher tout l'ouvrage ensemble, au lieu propre [j'entends] mis en oeuvre en la galerie mesme" (*CDR*, III, 319–20). But, in a reversal of Rembrandt's enterprise, perhaps some of what looks to be by his studio might be by Rubens himself!

3. For the 1685 purchase by Louis XIV, Rooses, IV, 71. The prior history is obscure: in 1653 "Een groote boerenbruyloft" by Rubens is inventoried as no. 12 in the belongings of the artist/dealer(?) Jeremiah Wildens; in 1657 "eenen boeren kermisse" by Rubens, as well as a copy, are in the collection of Wildens's half-sister, Susanna Willemssens, *Bulletijn-Rubens*, V, 5, 309–10; it has also been suggested that the *Kermis* was one of two Flemish weddings mentioned in a 1636 inventory (Held 1986, p. 146. Neither Held nor I can verify the source of the reference).

4. John Ruskin, *Notes on the Louvre*, 1849, in *The Works of John Ruskin*, ed. E.T. Cook and Alexander Wedderburn, 39 vols., London 1903–12, XII, 470–1.

5. "A peasant bacchanal," Julius Held and Donald Posner, *17th and 18th Century Art*, New York, n.d., 210; "This rustic Bacchanalian scene," Emile Michel, *Rubens: His Life, His Work, and His Time*, tr. E. Lee, 2 vols., London and New York, 1899, I, 247; "Il a celebré la Vénus rustique des Flandres," Rooses, *Rubens: sa vie et ses oeuvres*, Paris, 1903, 595.

6. Michel, *Rubens: His Life, His Work, and His Time*, I, 321, indexes "love of revolting subjects" as a topic under "Rubens." Jacob Burckhardt, *Erinnerung aus Rubens*, Basel, 1898, 260; *Recollections of Rubens*, tr. Mary Hottinger, London, 1950, 127–8.

7. The Prado peasant dance was listed in the inventory drawn up after Rubens's death as "Une danse des paysans Italiens" (Muller, p. 115). As the title might suggest, all the peasants are physiognomically refined. The women appear in the elegant dresses with which, in the 1630s, Rubens evoked contemporary well-to-do society, while at least two of the youths sport wreaths or animals skins appropriate to Bacchus and his train. Rubens here, it seems, deserted the tradition of the Flemish/German kermis and the problems it presented to him. A more coherent but less absorbing painting resulted. See the entry on this *boerendans* by Kristin Belkin in *De Vlaamse Schilderkunst in het Prado*, ed. A. Balis, M. Díaz Padrón, C. Van de Velde, H. Vlieghe, Antwerp, 1989, 170–1.

8. The *Kermis* reproduced in black and white with twenty-one details is an unusual publication of the Laboratoire de Musée du Louvre (J. Dupont, *P.P. Rubens: La Kermesse Flamande*, Brussels and Paris, 1938).

9. In the absence of any firm evidence, a range of dates has been proposed for the painting of the *Kermis*: 1620–3 (Evers I, 248); 1630–2 (Held); 1636 (Rooses, IV, 71)). Maybe 1631 was the year of the *Kermis*: in 1631 Rubens bought a Brouwer *boerendans* which was essential to the design, and in December 1634 Rubens wrote that three years earlier he had renounced all of his public duties for painting (*CDR*, VI, 81). The picture looks to be all by Rubens's hand, but for a possible collaborator in the landscape and still life, see Held 1986, p. 145.

10. "J'ay perdu en sa personne un des plus grans amys et patrons que j'avoys au monde comme je puis tesmoigner par une centurie des ses lettres." (In him I have lost one of the greatest friends and patrons I had in the world as I can prove by a hundred letters from him.) (*CDR*, v, 340; Magurn, p. 369).

11. Original letter in Italian of 13 January 1631 to Jan Woverius (Magurn, pp. 370–1; not in *CDR*).

12. See John Rupert Martin, *The Decorations for the Pompa Introitus Ferdinandi*, Corpus Rubenianum Ludwig Burchard, xvi, London and New York, 1972, and Elizabeth McGrath, "Rubens's *Art of the Mint*," *Journal of the Warburg and Courtauld Institutes*, xxxvii, 1974, 191–217, and "Le Déclin d'Anvers et les Décorations de Rubens pour L'Entrée du Prince Ferdinand en 1635," in *Les Fêtes de la Renaissance III*, ed. Jean Jacquot and Elie Konigson, Paris, 1975, 173–86.

13. By framing the stage with the Industry and Comus as positive figures, Rubens disrupts the conventional sequence of Prosperity leading to Excess, to Hubris, to Poverty, to Industry. Elizabeth McGrath has suggested to me at least two precedents in Antwerp civic festivities for a positive view of excessive/bacchic goings on: (1) the results of Peace depicted as the Three Graces together with Bacchus and Venus in the publication of a 1661 Landjuweel (drama festival) (*Spelen van Sinne*, Antwerp, 1562, fol. Tt ii[v]); (2) the 1566 Antwerp *ommegang* or civic procession in which a festive image of a *Bonne Chère* or *Grasse Cuisine* (literally fat kitchen) succeeded the vanquishing of Mars (see Sheila Williams and Jean Jacquot, "Ommegangs Anversois du Temps de Bruegel et de van Heemskerk," in *Fêtes et Cérémonies au temps de Charles Quint*, Paris, 1960, 361–2).

14. For the familial aspect of this and other Rubens bacchanalian images, Lisa Rosenthal, "The *Parens Patriae*: Familial Imagery in Rubens's *Minerva Protects Pax from Mars*," *Art History*, 12, 1989, 22–38.

15. See Adriaan Verhulst, *Précis de L'Histoire Rurale de la Belgique*, Brussels, 1990.

16. Jan Bruegel, Rubens's friend and colleague, and father-in-law to David Teniers, also offers precedent for painting a seigneurial view of the peasant. His paintings of Albert and Isabella attending a peasant wedding and peasant dance (Prado, Madrid) register the rulers' public policy at the time and the painter's role in sustaining it. But Teniers offers a closer analogue to Rubens's social position as (potential) courtier and (actual) painter/landowner. For a nuanced account of Teniers in Flemish country-house society, Faith Paulette Dreher, "David Teniers II Again," *Art Bulletin*, LIX, 1977, 108–10, and "The Artist as Seigneur: Chateaux and Their Proprietors in the Work of David Teniers II," *Art Bulletin*, LX, 1978, 682–703;
 Rubens's explanation of his choice of a second wife: "E presi una moglie giovine di parenti honesti pero cittadini benche tutti volevano persuadermi di casarme in corte ma io temeva commune illud nobilitatis malum superbiam praesertim in illo sexu, et percio mi piacque una che

non s'arrosserebbe vedendomi pigliar gli penelli in mano et a drie il vero il tesoro della pretiosa libertà mi parve duro di perdere col cambio delli abracciamenti di una vecchia." (*CDR*, VI, 82). (I have taken a young wife of honest but middle-class family, although everyone tried to persuade me to make a Court marriage. But I feared Pride, that inherent vice of the nobility, particularly in that sex, and that is why I chose one who would not blush to see me take my brushes in hand. And to tell the truth, it would have been hard for me to exchange the priceless treasure of liberty for the embraces of an old woman) (Magurn, p. 393).

17. The bridal crown, apparently confirming the subject as a village wedding, was noted by Emil Kieser, "Die Rubensliteratur seit 1935," *Zeitschrift für Kunstgeschichte*, 10, 1941–2, 312, and again by Hella Robels, "Die Niederländische Tradition in der Kunst Rubens," Inaugural-Dissertation, Cologne, 1950.

18. Held 1986, 145–6, for the relationship between the dancers in the *Kermis*, the drawing for it, and the dancing satyrs/nymphs in the *Worship of Venus*. For the several reasons for dating the three pictorial campaigns as beginning after 1630 and ending after 1635, *Peter Paul Rubens: Ausstellung zur 400. Wiederkehr seines Geburtstages*, Vienna, 1977, 127–32. Another instance of the bacchic/pastoral link is Rubens's substitution of a shepherd for the river-god lounging on a distant hill in his transformative copy of Titian's *Bacchanal of the Andrians* (pl. 96).

19. Horace translation from Steele Commager, *The Odes of Horace: A Critical Study*, New Haven, Conn., 1962, 90. Commager suggests a pun on libero/Liber or Bacchus which matches, in manner of using words, the economy of Rubens's pictorial mode.

20. For the Daumier copy, signed and dated 1848, which was destroyed in a fire soon after its discovery in the Paris flea market in 1950, see Jean Adhémar, *Daumier*, Paris, 1954, pl. 27.

21. *CDR*, VI, 237.

22. Braque's comment about Picasso was made after their working years together, probably after the War (quoted by Theodore Reff, "The Reaction Against Fauvism: The Case of Braque," in *Picasso and Braque: A Symposium*, New York, 1992, 38).

23. For Rubens's family in general, P. Génard, *P.P. Rubens: aanteekeningen over den grooten meester en zijne bloedverwanten*, Antwerp, 1877, and pp. 224ff. for Jan Rubens and the problem about Christine von Diez; for Jan Rubens's affair, Hans Kruse "Wilhelm von Oranien und Anna von Sachsen. Eine fürstlichen Ehetragödie des 16 Jahrhunderts," *Nassauische Annalen, Jahrbuch des Vereins für Nasssauische Altertumskünde und Geschichtsforschung*, 54, 1943, 59ff., and further, Hans Kruse "Christine von Diez, die natürliche Tochter des Jan Rubens und der Prinzessin Anna von Sachsen, Der Gemahlin Wilhelms I. von Oranien, und ihre Nachkömmlinge," *Siegerland*, 1937, 135–40.

24. See Michael Jaffé, *Rubens and Italy*, Ithaca, 1977; for painting technique, Hubert von Sonnenburg and Frank Preusser, *Rubens: Gesammelte Aufsätze zur Technik*, Munich, 1979. It would be nice to feel able to cite,

in this context, the often quoted boast Rubens made in a letter to the effect that he regarded the whole world as his country. He might well have felt this, but the remark was made in the interest of self-promotion in a particular context. Differentiating himself from great rulers (the English Prince Charles and the Spanish Princess Infanta Maria) whose allegiances often cool, Rubens, by contrast, hoped to feel welcome everywhere, "Mais, j'entends (ceteris partibus) que j'estime tout le monde pour ma patrie; aussi je croy que je serois le très bien venu partout" (*CDR*, III, 320).

25. Rubens apparently talked about art in Italian or employing Italian terms even when the person he was talking to, like Sir Theodore de Mayerne, the English physician and author of a valued manuscript on painting technique, knew Dutch well. See Hugh Trevor-Roper, "Mayerne and his Manuscript," in *Art and Patronage in the Caroline Courts: Essays in Honour of Sir Oliver Millar*, ed. David Howarth, Cambridge, 1993, 272.

On occasion, Rubens also inscribed his drawings in Latin or Italian (Held 1986, 38–40). But Flemish seems to been reserved either for notes about things internal to a particular drawing or for visual and pictorial concerns such as light and color.

For the final letter to his assistant written in Flemish, *CDR*, VI, 281–2; Magurn, p. 415.

26. *CDR*, III, 295.

27. See Martin, *The Decorations for the Pompa Introitus Ferdinandi*; Kristin Lohse Belkin, *The Costume Book*, Corpus Rubenianum Ludwig Burchard, XXIV, London and Philadelphia, 1978; Muller, pp. 44, 63–4, for a possible portrait gallery. I owe the suggestion about feudal obligation to Margaret Carroll who points out that Rubens pleaded the case of Marie de' Medici in these terms (*CDR*, V, 406; Magurn, p. 376).

28. *Fragment eener Autobiographie van Constantijn Huygens*, ed. J.A. Worp, *Bijdragen en Mededeelinghen van het Historisch Genootschap*, XVIII, 1897, 71–2; *CDR*, IV, 375, for one of many references to *Ollandesi*.

29. For Joachimi's report and Dorchester's letter, *CDR*, V, 277–9, 288–9. See also Hans Gerhard Evers, "Der Besuch von Rubens beim Holländischen Gesandten Albrecht Joachimi am 5 März 1630," in Evers II, 289–97. While acknowledging the deep incompatibility of their positions, Evers's sentiment is that Rubens takes a stand for peace while Joachimi is more narrowly protective of the Dutch.

30. *CDR*, VI, 233–4. The painting is probably no. 94 in the Rubens inventory, "Un berger caressant sa bergere," now in the Alte Pinokothek, Munich; see Muller, p. 114.

31. For the anger directed at Rubens by the duke of Aerschot, a leader of the conspiratorial nobles, when it was learned that the archduchess granted him a special passport go to The Hague on her behalf, *CDR*, VI, 34–5. For a modern historical account sympathetic to the principle of linguistic nationalism (itself replacing the religious nationalism of Motley), see Pieter Geyl, *The Netherlands in the 17th Century*, 2nd ed., London, 1961, 94ff.

32. See Svetlana Alpers, "Bruegel's Festive Peasants," *Simiolus*, 6, 1972–3, 163–76; Margaret D. Carroll, "Peasant Festivity and Political Identity in the Sixteenth Century," *Art History*, 10, 1987, 289–314. The interpretive issue – peasants as representative or as examples of misbehavior – is still alive and well: see, for example, *Literatur und Volk im 17. Jahrhundert: Probleme populärer Kultur in Deutschland*, ed. W. Brückner, P. Blickle, D. Breuer, Wiesbaden, 1982.

33. For the history of the language, B.C. Donaldson, *Dutch: A Linguistic History of Holland and Belgium*, Leiden, 1983; for Lipsius's Protean religious and political allegiances, Mark Morford, *Stoics and Neostoics: Rubens and the Circle of Lipsius*, Princeton, 1991; for the clash of attitudes towards the Flemish language, see H. Pirenne, *Histoire de Belgique*, IV, Brussels, 1911, 453–60, who quotes from the 1653 *Questiones quod libeticae* of Geulinx; Guilliam Ogier, *De Gulsigheydt*, ed. Willem van Eeghem, Antwerp, 1921.

34. See Benedict Anderson, *Imagined Communities: Reflections on the Origins and Spread of Nationalism*, 2nd, rev. ed., London and New York, 1991 (first published 1983); E.J. Hobsbawm, *Nations and Nationalism Since 1780: Programme, Myth, Reality*, Cambridge and New York, 1990.

35. Painter, merchant, knighted landowner: Rubens's class identification is combinatory, eluding any single classification. For a different view, Martin Warnke, *Kommentare zu Rubens*, Berlin, 1965.

36. On 4 March 1632, Brouwer and Rubens were signatories to a document, together with one Daniel Dagebroot, a dealer in pictures, in which Brouwer attests that he had painted only one "boerendans," and Rubens attests that he had bought it about one year before; see *Rubens-Bulletijn*, IV, 200–1. For Brouwer's "Une dance des villageois en un paysage" in Rubens's collection, Muller, p. 141. The painting is lost. However, a record of it remains in a drawing of a peasant dance, signed and dated 1659 by Matthijs van den Bergh, which names "Adriaen Brouwer haerlemiensis" as the inventor (pl. 33). For Brouwer, Konrad Renger, *Adriaen Brouwer und das niederländische Bauerngenre 1600–1660, Mit einem Beitrag zu Brouwers Maltechnik von Hubertus von Sonnenburg*, Munich, 1986.

37. It is interesting that while Rubens owned paintings by Bruegel, Jan van Eyck, and Lucas van Leyden among other northern painters, he did not collect works by sixteenth-century painters such as Gossart or Floris whose Italianate interests might seem to make them his obvious predecessors; see Muller, pp. 11–13.

38. For the drawings in general and the inscription in particular, Held 1986, 99, 145–6.

39. The *Kermis* has been photographed under infra-red light, but has not undergone radiography. Despite its size, the evidence suggests that its material structure—oil on prepared ground with no under-drawing – is closer to a sketch than to a painting by Rubens. A pair of drinkers drawn in just to the left of the musicians under the central tree probably show the way the figures looked as Rubens began. Elizabeth McGrath

suggested to me that another experimental picture with small figures is *The Conquest of Tunis by Charles V* (78 × 123, Berlin).

40. Roger de Piles, *Abregé de la vie des Peintres . . . et un Traité du Peintre parfait, de la connaissance des Desseins, & de l'utilité des Estampes*, Paris, 1699, 68, 67. This meaning of *liberté* was an unforced one at the time. See *Le Grand Dictionnaire de L'Académie Françoise*, 2nd ed., Paris, 1695, s.v. "Liberté": "Facilité heureuse, disposition naturelle. Grande liberté d'action. la liberté de la langue. la liberté de la parole" etc.

NOTES TO CHAPTER 2

1. John Ruskin, "Notes on the Louvre," in *The Works of John Ruskin*, ed. E.T. Cook and Alexander Wedderburn, 39 vols., London, 1903–12, XII, 470–1.
2. See *Rubens-Bulletijn*, II, 166, for the memoire sent by Philip Rubens to Roger de Piles which lists *la Conversation* as one of the works Rubens painted in the 1630s. This title, often amplified as "Conversatie à la mode," is repeated in subsequent Antwerp inventories. For the interesting suggestion that Rubens himself was borrowing from French pictorial sources, see Elise Goodman, *The Garden of Love as "Conversatie à la Mode"*, Amsterdam and Philadelphia, 1992. It seems that reciprocity ruled: Rubens's taste for French art is returned, though in a different form, in the French taste for his works. For an overview, see *Rubenism*, catalogue of an exhibition of the Department of Art, Brown University and the Museum of Art, Rhode Island School of Design, 1975.
3. Watteau began the transformation with a drawing of a woman, the reverse of this, which he used for the woman dancing in the *Fêtes vénitiennes* (K.T. Parker and J. Mathey, *Antoine Watteau: Catalogue complet de son oeuvre dessiné*, 2 vols., Paris, 1957, no. 545).
4. For a compendium of de Piles's multiple publications of the Richelieu collection, Bernard Teyssèdre, "Une Collection française de Rubens au XVIIe siècle: Le Cabinet du duc de Richelieu décrit par Roger de Piles (1676–1681)," Gazette des Beaux-Arts, VIIème, LXII, 1963, 241–300; and, more generally, his *Roger de Piles et les débats sur le coloris au siècle de Louis XIV*, Paris, 1957. For the correspondence with Philip Rubens on which de Piles based his life of Rubens, *Rubens-Bulletijn*, II, 157–75.
5. The major writings on art by Roger de Piles in order of publication are: Charles-A. Dufresnoy, *De Arte Graphica–L'Art de la peinture, traduit en François avec des remarques* [by de Piles], Paris, 1668; *Dialogue sur le coloris*, Paris, 1673; *Conversations sur la connaisance de la peinture*, Paris, 1677; *Dissertations sur les ouvrages des plus fameux peintres* , Paris, 1681; *Abrégé de la vie des peintres*, Paris, 1699, 2nd ed., 1715; *Cours de peinture par principes*, Paris, 1708.
6. Bernard Teyssèdre, *L'Histoire de l'art vue de grand siècle: Recherches sur l'Abrégé de la vie des peintres, par Roger de Piles (1699) et ses sources*, Paris, 1964.

7. *Abrégé de la vie des peintres*, 545.

8. See Thomas Puttfarken, *Roger de Piles' Theory of Art*, New Haven and London, 1985.

9. *Dialogue sur le coloris*, 25.

10. *Cours de peinture par principes*, 3.

11. *Dialogue sur le coloris*, 69.

12. *Dialogue sur le coloris*, 5.

13. *Dialogue sur le coloris*, 67.

14. *Cours de peinture par principes*, 3 and 6.

 Though it is admittedly not quite fair, it suits my purposes here to treat de Piles's notion of art as falling into two discrete parts: one part concerned with the viewer, the other with the painting in view. There is no easy or logical fit between his evocation of the viewer's experience of true painting and his notion of "disposition" or what he calls "l'économie du tout-ensemble" of the work. The two are, however, linked by an interest in what we might today call the pictorial. Pictorial composition is de Piles's second application of his interest in "le beau fard." The illustrations of a group of balls and of a bunch of grapes that de Piles includes in the *Cours* are not introduced as examples of the viewer's surprising encounter with a picture, but in support of the "tout ensemble." The use of balls or grapes in an optical context to demonstrate how we see is unremarkable. But de Piles uses the balls and grapes to make the radical suggestion that *pictorial unity* can be constituted in-dependently of reference to the subject of a picture. Though de Piles did not share Chardin's empirical understanding of vision, his definition and this illustration of "tout ensemble" is consistent with Chardin's attentive-ness to pictorial composition as such, as well as with Chardin's practice of composing ambitious paintings out of ordinary objects.

 Two recent studies of de Piles diverge on just these points – one turning inward to the painting to focus on pictorial unity, the other outward from it to explicate the rhetorical nature of its address to the viewer and the calling of the viewer into conversation. For de Piles's proposals about pictorial composition, Puttfarken, *Roger de Piles' Theory of Art*. For the outward turn, Jacqueline Lichtenstein, *La Couleur éloquente*, Paris, 1989, Engl.tr., *The Eloquence of Color: Rhetoric and Painting in the French Classical Age*, Berkeley, 1993. I am in essential agreement with Lichstenstein's account of de Piles's emphasis on the viewer's experience of painting. But her interest is in the philosophical setting of de Piles's definition of painting, mine is in its pictorial setting and its afterlife in France.

15. *Cours de peinture par principes*, 10. It is not certain which, if any, of the surviving paintings fitting de Piles's description, was the one that he bought: *The Kitchen Maid*, National Museum, Stockholm; *Girl at a Window*, Dulwich Picture Gallery, London; *A Girl with a Broom* (Carel Fabritius? Rembrandt workshop?), National Gallery of Art, Washington, D.C.; *Young Woman at an Open Window* (Samuel van Hoostraten? Rembrandt Workshop?), The Art Institute, Chicago. Curiously, the first

three were in France in the eighteenth century. See Görel Cavalli-Björkman, "Rembrandt's *Kitchen Maid*. Problems of Provenance and Iconography," and Arthur Wheelock, "*A Girl with a Broom*: A Problem of Attribution," in *Rembrandt and his Pupils*, Stockholm, 1993, 68–76 and 142–55.

16. *Cours de peinture par principes*, 12–13.

17. De Piles intended to write a sequel to his *Conversations* of 1677 which he considered part of a series of writings in the dialogue form initiated with the *Dialogue sur le coloris*; see Teyssèdre, *Roger de Piles et les debats sur le coloris au siècle de Louis XIV*, 647.

18. *Cours de peinture par principes*, 3.

19. *Dialogue sur coloris*, 64.

20. For an account of the erotic implications of the discussion of color that relates de Piles specifically to rhetorical tradition see Lichtenstein, *The Eloquence of Color*.

21. The centrality of conversation to French literary culture is the subject of a number of publications by Marc Fumaroli, see, for example, *Le Genre de genres littéraires français: La Conversation*, The Zaharoff Lecture for 1990–1, Oxford, 1992. For the new conversational aristocratic culture and women's role in it, Carolyn C. Lougee, *Le Paradis des Femmes: Women, Salons and Social Stratification in Seventeenth-Century France*, Princeton, N.J., 1976, and Elizabeth C. Goldsmith, *"Exclusive Conversations": The Art of Interaction in Seventeenth-Century France*, Philadelphia, 1988. For paintings of talk and love replacing the power of arms, and the new pleasure taken in love even by Diana, Katie Scott, "D'un siècle à l'autre," and Stephen Z. Levine, "Voir ou ne pas voir: le mythe de Diane at Actéon au XVIII siècle," in *Les Amours des dieux: La Peinture mythologique de Watteau à David*, ed. Colin Bailey, Paris and Fort Worth, 1991, xxxii–lii and lxxiii–xcv. But for the limits of conversation as a prospect for women, Claude Dulong, "De la Conversation à la Création," in *Histoire des femmes en Occident*, 3, XVI–XVIII Siècles, ed. Natalie Zemon Davis and Arlette Farge, Paris, 1991, 403–25.

22. "Car les sept première figure [*sic*] à main gauche vous diront tout ce qui est icy escrit et tout le reste est de la mesme estoffe: lisés l'istoire et le tableau, afin de cognoistre si chasque chose est apropriée au subiet" (Ch. Jouanny, *Correspondance de Nicolas Poussin*, in *Archives de l'art français* N.S. v, 1911, 21.

23. Anthony Blunt, *Nicholas Poussin*, 2 vols., New York, 1967, I, x. For counter-arguments on behalf of Poussin as a painter, Michael Podro, "Depiction and the Golden Calf," *Philosophy and the Visual Arts*, ed. Andrew Harrison, Dordrecht, 1987, 3–21; and Oskar Bätschmann, *Nicolas Poussin: Dialectics of Painting*, London 1990 (first German ed., 1982).

24. For Sainte-Palaye's views about art, Lionel Gossman, *Medievalism and the Ideologies of the Enlightenment: The World and Work of La Curne de Sainte-Palaye*, Baltimore, 1968, 127ff.

25. E.H. Gombrich, "Norm and Form: The Stylistic Categories of Art

History and their Origins in Renaissance Ideals," in *Norm and Form: Studies in the Art of the Renaissance*, London, 1966, 81–98.

26. Diderot, *Salons*, 4 vols., ed. Jean Seznec and Jean Adhémar, Oxford, 1963, III, 76 and 189–90. For Diderot's comparison considered in terms of expression versus absorption, Michael Fried, *Absorption and Theatricality: Painting and Beholder in the Age of Diderot*, Berkeley, 1980, 115–17.

27. "Mettons à part tous les principes de l'art; il disparait ici, et ne laisse apercevoir que la nature même" (an anonymous critic quoted by Thomas Crow, "The *Oath of the Horatii* in 1785," *Art History*, I, 1978, 430).

28. Richard Verdi, "Poussin's *Eudamidas*: Eighteenth Century Criticism and Copies," *Burlington Magazine*, CXIII, 1971, 512–24.

29. Carol Duncan, "Ingres' *Vow of Louis XIII* and the Politics of the Restoration," in *Art and Science in the Service of Politics*, ed. Henry A. Millon and Linda Nochlin, Cambridge, 1978, 84.

30 The problem was visible at the exhibition recorded in the catalogue *Les Amours des dieux*, ed. Bailey.

31. Ferdinand de Saussure, *Course in General Linguistics*, tr. Wade Baskin, New York, 1966. The notes based on lectures Saussure delivered between 1906 and 1911 were posthumously published in 1916. Heinrich Wölfflin, *Kunstgeschichtliche Grundbegriffe*, Munich, 1915.

32. For a less specialized reading of Wölfflin, Michael Podro, *The Critical Historians of Art*, New Haven and London, 1982.

NOTES TO CHAPTER 3

1. For Silenus and the Sileni in antiquity see Pauly-Wissowa, *Realencyclopaedie der Klassischen Altertumswissenschaft*, Stuttgart, 1894–1937, s.v. "Silenos und Satyros." For the comic figure, Ovid, *Ars Amatoria*, I, 535–46, *Fasti*, I, 399ff., III, 745ff., and VI, 333ff.; for his capture by peasants and delivery to King Midas, Ovid, *Metamorphoses*, XI, 90ff., also, among others, Philostratus, *Imagines*, I, 22. His prophetic truth-telling, in the pessimistic form that the best thing is not to be born and the next best to die soon, in Xenophon, Theopompus, and Sophocles in *Oedipus at Colonnus* and more. The verses sung after the binding up by shepherds/nymphs constitute much of Virgil's sixth Eclogue. The literature on Silenus in antiquity is contained within the huge literature on Dionysus/Bacchus. For a summary of this, with bibliography, see *Masks of Dionysus*, ed. Thomas H. Carpenter and Christopher A. Faraone, Ithaca, 1993.

2. The works in the order cited are: (1) *Silenus Carried by a Satyr and Two Fauns*, after Mantegna, Louvre, Paris (drawing) (as drawing by another hand corrected by Rubens, *Rubens Cantoor: een verzameling rekeningen onstaan in Rubens' atelier*, Antwerp, 1993, 222, n. 6); (2) *Bacchanal with Silenus*, with Jan Bruegel(?) after Mantegna, Pommersfelden (painting); (3) *Drunken Silenus*, after Annibale Carracci, Chatsworth, Devonshire Collections (drawing); (4) *Dream of Silenus* (also called a Satyr),

Akademie, Vienna (painting); (5)*Bacchanal*, formerly Hermitage, St. Petersburg, moved to Pushkin Museum, Moscow, in 1930 (painting); (6) Workshop of Rubens, *Drunken Silenus*, National Gallery, London (painting); (7) *Drunken Silenus*, Alte Pinakothek, Munich (painting); (8) (workshop) *Drunken Silenus*, Gemäldegalerie Alte Meister, SchlossWilhelmshöhe, Kassel (painting); (9) *Drunken Silenus*, Palazzo Durazzo-Pallavicini, Genoa (painting); (10) *Nymphs and Satyrs*, Prado, Madrid (painting); (11) *Nature Adorned by the Graces*, Corporation Art Gallery, Glasgow (painting); (12) *The Triumph of Bacchus*, Boymans-Van Beuningen Museum, Rotterdam (oil sketch); (13) *Bacchanal*, Palazzo Bianco, Genoa (painting) (confirmed as by Rubens after cleaning and conservation; see *Venere e Marte di Pier Paolo Rubens*, Centro Didattico di Palazzo Bianco, Quaderno no. 8, Genoa, 1986).

3. The Virgil drawings are: (1) *Bacchanal*, Antwerp, Stedelijk Prenten-kabinett, engraved (as Van Dyck) when in the collection of the comte de Caylus. Is this perhaps Marsyas flayed instead of Silenus bound? It could, in a Rubensian manner, be a generic representation able to be seen as both. Like Silenus, Marsyas was a follower of Bacchus and an artist when playing his flute. Furthermore, like Silenus, Marsyas is invoked by Alcibiades in Plato's *Symposium* to describe Socrates. The scale is tipped in favor of Silenus by an Antoine Coypel painting of Silenus and Aegle evidently based on Rubens's drawing when it was collection of the comte de Caylus (pl. 109); (2) *Silenus, Aegle, and Other Figures*, Windsor Castle. See Evers II, 223ff., and Held 1986, 90, no. 53, and 101, no. 81.

4. According to Palomino, Ribera's *Drunken Silenus* was painted for Gaspar de Roomer, a Flemish merchant living in Naples. The etching after the painting is dated 1628.

The black man (or, more correctly, Ethiopian, as Elizabeth McGrath points out in a forthcoming study) accompanying Silenus in Rubens's painting first appears behind him, obviously offering support, in *Nature Adorned by the Graces* (pl. 69). (His head is that of a particular man Rubens studied four times in oil on panel, since transferred to canvas, in the Musées Royaux des Beaux-Arts, Brussels.) Though the black man's supporting arm must pass between himself and Silenus, there is little place for the rest of his body. To many viewers something in addition to support seems to be suggested in the re-casting of the pair of men in the Munich painting.

If there were ancient authority, in texts or images, for such an incident of anal sex it would surely appear in one of the many studies in and around the subject of homosexuality, rape, and other sexual encounters in antiquity. The sexual act between older men and boy lovers was honored but unrepresented, in contrast to a certain interest (apparently not widespread) in the representation of sexual encounters, including anal penetration, between men and female prostitutes. (The few black-figure vases showing anal intercourse between youthful men were made, so it is said, for the Etruscan not the Athenian market!) Even with the license of the mythic world of satyrs, buggery as such is only rarely depicted. The

originating modern text is K.J. Dover, *Greek Homosexuality*, Cambridge, Mass., 1989, first published in 1979. See also H.A. Shapiro, "Eros in Love: Pederasty and Pornography in Greece," in *Pornography and Representation in Greece and Rome*, ed. Amy Richlin, New York and Oxford, 1992.

Ancient evidence notwithstanding, it appears that the support offered in the Glasgow painting (pl. 69) has changed into a kind of wanton aggressiveness or rape which is repeated in the pair of rutting goats. Rubens's invention extends and deepens the mockery of Silenus. In a kind of dark comic turn, it unites with the evident effects of wine to provoke his creative state.

5. "Vne piece d'un Silene enyuré [*sic*] auec des Satyres & autres figures," or "Druncken Silenus" in the English version, is no. 170 in the inventory of works in Rubens's possession drawn up after his death; see Muller, p. 124. A note on one of the many drawings in Copenhagen made after Rubens by William Panneels, an assistant left with the care of the house during the artist's absence 1628–30, locates the painting in a small hall: "vanden selenis van rubbens dit int saelkent stoent," see *Rubens Cantoor*, 170. It is next recorded in the collection of the duc de Richelieu (the *Silenus* is sometimes confused with the *Bacchus* now in Russia, also owned by Richelieu, which passed from Rubens's estate to Philip Rubens, his nephew); by 1716 it was in Düsseldorf, from whose Gallery it was brought to Munich in 1806. Its measurements are 212 × 213.

For the discovery that the painting was made in three stages see Hubert von Sonnenburg and Frank Preusser, *Rubens: Gesammelte Aufsätze zur Technik*, Munich, 1979 (first published in *Maltechnik-Restauro*, 2 and 3, 1979).

It is generally assumed that the painting was begun about 1617/18, but when did Rubens finish working on it? The existence of a copy of the first stage in Kassel (pl. 79) suggests that it was not completed in a single campaign. The 1628–30 Panneels drawing after the human leg of Silenus establishes the date by which the painting was at least in its second stage; see *Rubens Cantoor*, 179 and fig. 74. Rubens certainly left off enlarging and working on the Munich painting before his 1628–30 absence. Philip Rubens in his correspondence with de Piles refers to "Le Silenus, 1618" ("La Vie de Rubens par Roger de Piles," *Rubens-Bulletijn*, II, 166.) This could as well refer to the beginning as to the ending of the work. However, Stephan-Maaser, p. 296, notes that Van Dyck's destroyed version of a post-Kassel stage (pl. 89) must date from 1618/19 when he was still Rubens's assistant. But there is no evidence to support the 1626 date in the Munich catalogues; see *Alte Pinakothek Munich: Explanatory Notes on the Works Exhibited*, Munich, 1986, 459. Between 1618 and 1620 seems a good bet.

The first book-length study of the Munich painting is Reinhild Stephan-Maaser, *Mythos und Lebenswelt: Studien zum "Trunkenen Silen" von Peter Paul Rubens*, Münster and Hamburg, 1992. It is a learned compilation and thoughtful account of the texts and images that were

potential sources for Rubens's making of the picture, with a reception account of its *Bildrhetorik*. Neither Rubens's engagement with Virgil's sixth Eclogue, nor his manner of representing the body is pressed. For earlier studies, Emil Kieser, "Rubens Münchner Silen und Seine Vorstufen," *Münchner Jahrbuch der bildenden Kunst*, N.F. XIII, 1938/9, no. 4, 185–202, and Evers II, 221–48, "Der 'Träumende Silen' der Wiener Akademie," "Nymphen und Satyrn," and "Zu den Silenszügen"; also some fine pages on the Munich painting in Evers I, 201–10, where he notes that his work on Rubens began with a paper on the Munich *Silenus*, also the subject of his 1932 Habilitationschrift. (Serious questions about Evers's politics during the Second World War explains a general silence about the remarkable intelligence and nuance of his writing.)

6. See Bernard Teyssèdre, "Une Collection française de Rubens au XVII siècle: Le Cabinet du duc de Richelieu décrit par Roger de Piles, *Gazette des Beaux-Arts*, LXII, 1963, 263–4. This is the most accessible publication of de Piles on the paintings collected by Richelieu.

7. Rubens wrote to Junius, ". . . illa quae sub sensum cadunt acrius imprimuntur et haerent, et exactius examen requirunt atq. materiam uberiorem proficiendi studiosis praebent quam illa quae sola imaginatione tanquam somnia se nobis offerunt et verbis tantum adumbrata ter frustra comprensa (ut Orpheum Euridices imago) (*CDR*, VI, 179); or, "Those things which are perceived by the senses produce a sharper and more durable impression, require a closer examination, and afford a richer material for study than those which present themselves to us only in the imagination like dreams, or so obscured by words that we try in vain to grasp them (like Orpheus the shade of Eurydice)" (Magurn, p. 407).

 The drawings after the marble Silenus in Dresden once owned by Prince Agostino Chigi are: (1) *Silenus* (from the side), British Museum, London (see Held 1986, 81); (2) *Silenus* (from the front), Musée des Beaux-Arts, Orléans. The stumbling *Silenus* drawn after part of the frieze of the Borghese Vase is in the Kupferstichkabinett, Dresden. For the Orléans and Dresden drawings, see Michael Jaffé, *Rubens and Italy*, Oxford, 1977, 55, 83. For the complex problems of the drawings of Silenus heads, Julius Held, *Rubens: Selected Drawings*, 2 vols., New York, 1959, I, 160–1 (not in Held 1986).

8. The physiology of creativity as Rubens and his contemporaries understood it went back to ancient texts. Aristotle in *Problems*, XXX (often cited for its discussion of melancholy) compares the naturally atrabilious (or black bile) state of all those eminent in philosophy, politic, poetry, or the arts to being drunk on red wine, the effect of which, on this account, is to heat the blood and fill the body with air (pneuma). It might be that Silenus, his veins *inflated* (inflatum) with yesterday's wine, as Virgil describes him in l. 15 of the sixth Eclogue, is an example of one such. Though it is consistent with this, Rubens's depiction of Silenus appears to be more immediately grounded in what he had to hand in his depiction of flesh.

9. For the inscriptions on Rubens's house, see F. Baudouin, *Rubens House:*

170

A Summary Guide, Antwerp, 1967.

On the subject of Rubens and drinking, Philip Rubens, his nephew, in a letter to de Piles wrote that, "Il ne se donnoit jamais le passetems d'aller dans les compagnies où l'on *buvoit et jouoit*, en ayant toujours eu une aversion . . ." (*Rubens-Bulletijn*, II, 165). De Piles (on the basis of this?) notes, "Il avoit neantmoins une grande aversion pour les excès du vin et de la bonne chere, aussi bien que du jeu" (*Conversations sur la connaissance de la peinture*, Paris, 1677, 213–15).

There was, at Rubens's time as at most others, a negative moral lesson drawn from carousing. This has been invoked in an explanatory manner in the Rubens literature. But the captions on prints after Rubens works made for public sale are no more convincing about the simple admonitory nature of his paintings than are the captions on the prints made after Chardin, say, about the nature of his. "Ebrietas mentis membrorumque impedit usum,/SILENI ut scite fabula prisca docet/Exaurit nummos, Veneris, Martisque furores/Excitat, et mortem provocat ante diem"; or "Drunkenness hampers the use of the limbs and the intellect, as the old fable of Silenus recounts; it squanders money, stimulates the blind passions of Venus and Mars, and causes premature death." This caption, affixed to a Schelte à Bolswert engraving after a Silenus drawing by Rubens, has little to do (except by contrast) with the painting now in Munich. For the engraving, see C.G Voorhelm-Schneevoogt, *Catalogue des estampes gravées d'après P.P. Rubens*, Haarlem, 1893, 135, no. 138. For its proposed relevance to the Munich *Silenus*, see the handbook *Alte Pinakothek Munich*, Munich, 1986, 459, entry by U.K. (Ulla Krempel). For the moralism of bacchic captions, Konrad Renger, "Sine Cerere et Baccho friget Venus. Zu bacchischen Themen bei Rubens," in *Peter Paul Rubens: Werk und Nachruhm*, Augsburg, 1981, 105–35; for the general question, Elizabeth McGrath, "Rubens's *Susanna and the Elder* and moralizing inscriptions on prints," in *Wort und Bild in der niederländischen Kunst und Literatur des 16 und des 17 Jahrhunderts*, ed. Herman Vekeman and Justus Müller-Hofstede, Erfstadt, 1984, 73–80. For the Silenus of Rubens as anti-stoical, Martin Warnke, *Kommentare zu Rubens*, Berlin, 1965, 30ff. See also Elizabeth McGrath, "Pan and Wool," in *Papers Presented at the International Rubens Symposium, The Ringling Museum of Art Journal*, 1982, 52–69.

There is evidence that the "bacchaniste" Rubens was celebrated and imitated during his lifetime. The Moscow *Bacchanal* was featured in a number of seventeenth-century paintings of picture galleries and encyclopedic collections. The admiration extends from the unfortunate legacy in the mythological paintings of Jacob Jordaens, Rubens's one-time assistant and Antwerp successor, to the way Rubens was seen by Velázquez. In his so-called *Los Borrachos* (*Drinkers*), painted during or just after Rubens diplomatic visit to Madrid in the late 1620s, Velázquez takes up Rubens's bacchic theme along with his use of a white ground.

10. "However I should not like to be pressed to finish it, but ask that this be left to my discretion and convenience, in order to be able to do it with

pleasure" (Magurn, p. 243); or, as Rubens wrote it, ". . . soude idk niet gheyrne ghepressert syn maer bidde tselvighe te willen laeten tot mynder discretie ende commoditeyt ommet lust wt te vueren . . ." (*CDR*, VI, 211).

11. For the *Studies for a Drunken Silenus*, formerly collection of the late Count A. Seilern, see Held 1986, 113.

12. For marked photographs showing the stages of these and other paintings by Rubens, von Sonnenburg, *Rubens: Gesammelte Aufsätze zur Technik*.

13. Of the "force tout ensemble" de Piles writes, in part," [Silene] est au milieu du Tableau sous la principale lumiere, et entouré d'ombres de part et d'autre, ce que fait d'autant plus paroistre cette figure, qu'elle est peinte et coloriée d'une force et d'n artifice sans pareil. Le Peintre pour fair reüssir son Tableau dans cette intention a placé d'un costé un More qui pince le Silene à la fesse, et dont la couleur jointe aux autres corps ombrez que luy sont voisins, releve celle du Vieillard qui est fort esclairé . . ." (Teyssèdre,"Une Collection française de Rubens au XVII siècle", 263).

14. The paintings referred to are Piero di Cosimo's so-called, *The Misfortunes of Silenus*, Fogg Art Museum, Cambridge, Mass., and Giovanni Bellini, *Feast of the Gods*, National Gallery of Art, Washington, D.C.

15. Giulio Bonasone, *Cum Virtute Alma Concentit Vera Voluptas*, woodcut in Achilles Bocchi, *Symbolicae Quaestiones*, Bologna, 1573, I, no. X. For a discussion of the Silenus emblem of Achilles Bocchi and related neo-Platonic attitudes, see Stephan-Maaser, pp. 147–55. Though significant to his intellectual ambience, the Platonic sources, centrally the *Phaedrus*, that informed the account of the relationship between divine madness and creativity in neo-Platonic writers, were not directly engaged by Rubens in painting the *Silenus*.

16. *Socrates habitu Sileni* is the name used by Rubens in his index. See Marjon van der Meulen, *Peter Paulus Rubens Antiquarius: Collector and Copyist of Antique Gems*, Alphen and Rijn, 1975, 156, no. G.79, fig. XVI, B. An inscription in the artist's hand on the drawing of the heads notes it is a possible design for an ivory.

17. Rubens in the translation of de Piles: "La principale raison pourquoi les corps humains de notre tems sont differens de ceux de l'antiquité, c'est la paresse, l'oisiveté, & lepeu [*sic*] d'exercice que l'on fait: car la plûpart des hommes n'exercent leur corps qu'à boire & à faire bonne chere" (*Cours de peinture par principes*, Paris, 1708, 145–6).

18. For the drawing of the *Seated Nude Man*, Held 1986, 31, and 113, under no. 112. On the back of the mount an inscription attributed to Jonathan Richardson Sr., the first recorded owner, reads: "Silenus in a Bacchanal, the Picture is in a Gallery Fill'd with Pictures only of Rubens, the Elect. Palatine's at D———."

19. Rubens's practice of depicting solid flesh in men and women differs, as practice often does, from principles he set down in the text of his theoretical notebook on the human figure. There, not surprisingly for his time, Rubens begins with the primacy of the virile male body and, citing the determination of the best artists and sculptors, proceeds, among other

things, to distinguish female flesh from male musculature: "La forme virile est la vraie perfection de la figure humaine . . . pours le corps de la femme . . . la chair solide, ferme & blanche, teinte d'un rouge-pale, comme la couleur qui participe du lait & du sang . . . Il faut sur-tout éviter avec soin, soit dans ses membres, soit dans ses attitudes, toute roideur & apparence de muscles." For a record of Rubens's lost note-book, see *Théorie de la figure humaine, considérée dans ses principes, soit en repos ou en movement. Ouvrage traduit du latin de Pierre-Paul Rubens, avec XLIV Planches gravées par Pierre Aveline, d'après les desseins de ce célebre artiste,* Paris, Charles-Antoine Jombert, 1773. Quotations from pp. 9, 50, and 52. I owe the reference to Jeffrey Muller.

20. The letter Eakins wrote to his father from Madrid in 1869 is quoted by Sylvan Schindler, *Eakins*, Boston, 1967, 18–19. I owe the reference to William Stern.

21. Bowery as quoted by John Richardson, "Paint Becomes Flesh," *The New Yorker*, 13 December 1993, 142. Looking at Mantegna's Silenus copied by Rubens one might suppose, though of course one knows better, that it was in reference to such art that Bowery shaved his head as well as his body, and then, heavily, took his seat.

22. Coypel's painting was one in a series of paintings discussed in *Les Amours des dieux: La Peinture mythologique de Watteau à David,* ed. Colin Bailey, Paris and Fort Worth, 1991, 40–3; for the Van Loo *Silenus,* 334–9.

23. *Flaubert–Sand: The Correspondence*, tr. Francis Steegmuller and Barbara Bray, New York, 1993, 400.

24. For male writers who associate their creativity with a female body, Katharine Eisaman Maus, "A Womb of his Own: Male Renaissance Poets in the Female Body," in *Sexuality and Gender in Early Modern Europe*, ed. James Grantham Turner, Cambridge, 1993, 266–88.

25. For the artist before his painting, see in particular Michael Fried, *Absorption and Theatricality: Painting and Beholder in the Age of Diderot*, Berkeley, 1980, and *Courbet's Realism*, Chicago, 1990, and Richard Wollheim, *Painting as an Art*, Princeton, N.J., 1987, in particular Chapter 1, "What the artist does," 39–45.

26. The passages referred to are quoted from Friedrich Nietzsche, *The Birth of Tragedy*, tr. Walter Kaufmann, New York, 1967, 61ff., 42, 45, 50 and 64.

27. For Rubens's so-called "pocket-book" with quotations from Virgil, see G.P. Bellori, *Vite*, Rome, 1672, ed. E. Borea, Turin, 1976, 266f.; Michael Jaffé, *Van Dyck's Antwerp Sketchbook*, London, 1966, I, 16–19 and 301. For his recital of the *Aeneid* even as he painted, see Elizabeth McGrath in *Splendours of the Gonzaga*, ed. D. Chambers and J. Martineau, London, 1981–2, 214.

28. McGrath has generously not objected to my attempt to summarize her unpublished interpretation of the puzzling inscription which has (un-convincingly) been read before as, among other things, "vetula gaudens" or an amused old woman. (For a summary of previous readings, see Held 1986, 101.) The word "vitula" – which occurs in Eclogue 3, l. 85, near

a previous use of "Pierides" – is glossed by Pontanus with reference to Vitulina, the goddess of joy, and indexed with reference to "vitulare graece est voce laetari" or to shout or sing with joy. By these verbal connections *vitula* is related to *laetitia* or *gaudium*, hence Rubens's inscription "vitula–guad[ium]." But (this is no longer McGrath), if Rubens the Latinist is caught up by Pontanus's *definition* of an unusual word, could not Rubens as a reader of the *Eclogues* also have been interested in Virgil's *use* of the word from which Pontanus takes off. In Eclogue 3, l. 85 (the passage to which Pontanus's commentary led Rubens in following up on "Pierides"), Virgil actually uses the word "vitulam," which is the accusative of "vitula" meaning a *sacrificial heifer*. Given Silenus's captive situation in the drawing, is Rubens's inscription also, perhaps, recording the relevance to his Silenus of a bound sacrificial animal?

29. For Silenus's repertory as literary catalogue, Zeph Stewart, "The Song of Silenus," *Harvard Studies in Classical Philology*, LXIV, 1959, 179–205; for Silenus as Orphic poet, Godo Lieberg, *Poeta Creator: Studien zu Einer Figur der Antiken Dichtung*, Amsterdam, 1982 (27–9 for "condere bella"); for the wide-spread nature of the belief in his vatic powers, as confirmed in the discovery of a third-century mosaic depicting Silenus attended by Aegle and three youths, E. de Saint-Denis, "Le Chant de Silène à la lumière d'une découverte récente," *Revue de Philologie*, XXXVII, 1963, 23–40.

30. Sir William Sanderson, *Graphice*, London, 1658, 34; G.P. Bellori, *Vite* (Rome, 1672), ed. E. Borea, Turin, 1976, 267; Delacroix as quoted by Peter Campbell, *London Review of Books*, 28 January 1993, p. 17.

31. For Rubens's Samson and Delilahs in general, and the relationship to Perino del Vaga in particular, see Evers II, 151–66, and Julius Held, *The Oil Sketches of Rubens*, 2 vols., Princeton, N.J., 1980, I, 430–5, also noting the similarity of some of these figures.

32. *CDR*, III, 445; Magurn, p. 136. Walter Melion drew my attention to the curiously double-gendered nature of these remarks.

33. *Hercules and Omphale* and *Venus and Adonis* were noted as pendants in a Genoese collection. See Michael Jaffé, *Rubens in Italy*, Ithaca, 1977, 651.

34. For a different interpretation that is attentive to many of the same pictorial features, see Lisa Rosenthal, "Manhood and Statehood: Rubens's Construction of Heroic Virtue," *Oxford Art Journal*, 16, 1993, 92–111.

 The proximity between the Rubens Hercules drunk and his Silenus drunk can also be instanced in the difficulty of knowing which figure is depicted (pl. 64). See Hans Mielke and Matthias Winner, *Peter Paul Rubens: Kritischer Katalog der Zeichnungen*, Staatliche Museen Preussischer Kulturbesitz, Berlin, 1977, 112–13.

35. See Margaret D. Carroll, "The Erotics of Absolutism: Rubens and the Mystification of Sexual Violence," *Representations*, 25, 1989, 3–30, and "Ovid and the *Art of Love*," Chapter 5 of Elizabeth McGrath, *Subjects from History*, Corpus Rubenianus Ludwig Burchard, forthcoming.

Index

Photograph Credits

In most cases, the illustrations have been made from photographs and transparencies provided by the owners or custodians of the works. Those plates for which further credit is due are:

Scala: 1, 4, 6a, 7, 11, 32
Warburg Institute, University of London: 18, 20, 77, 89, 92
Staatliche Museen zu Berlin – Preusssischer Kurlturbesitz; photo Jörg P. Anders: 33, 44, 98, 99
Artothek: 34, 63, 95, 101
MAS: 35, 40, 70, 97, 113
© Photo RMN: 2, 24, 36, 37, 41, 47, 49, 51, 54, 58, 59, 60, 61, 73, 117
Alinari: 46
Bulloz: 55, 56
Bildarchiv Foto Marburg: 74
Courtauld Institute of Art, University of London: 75
Svetlana Alpers: 80
Sächsische Landesbibliothek Abteilung Deutsche Fotothek Dresden: 83 (Richter), 91 (Löbius)
Copyright IRPA-KIK, Brussels: 90
Photo C. Devleeshauwer: 109